ML 648.5 C498 Ciullo, Peter A., 1954-Baking soda bonanza

BONANZAS

Bananga S Bananga S

2nd Edition

Peter A. Ciullo

BAKING SODA BONANZA, 2ND EDITION. Copyright © 2006 by Peter A. Ciullo. All rights reserved. Printed in the United States of America. No part of this book may be used or reproduced in any manner whatsoever without written permission except in the case of brief quotations embodied in critical articles and reviews. For information, address HarperCollins Publishers, 10 East 53rd Street, New York, NY 10022.

HarperCollins books may be purchased for educational, business, or sales promotional use. For information, please write: Special Markets Department, HarperCollins Publishers, 10 East 53rd Street, New York, NY 10022.

FIRST EDITION

Designed by Emily Cavett Taff

Library of Congress Cataloging-in-Publication Data has been applied for.

ISBN-10: 0-06-089342-7 ISBN-13: 978-0-06-089342-2

06 07 08 09 10 WBC/RRD 10 9 8 7 6 5 4 3 2 1

648.5 C498

> In memory of Josephine Ciullo, Ida DeCiampis, and Alice Arcari, who brought dignity and love to good food and a clean home.

Ens. Ingrisos Grant of Strangers and Described of Constitution And Brown of Constitution and Constitution of Constitution and Constitution of Constitution and Constitution of Constitution of

Contents

ix Acknowledgments

xi Introduction: Baking Soda, Naturally

Baking Soda Rises

The Household Alternative

75
The Environmental Alternative

 $$8_{\mbox{\footnotesize 3}}$$ Baking and Baking Soda

103 Recipes

Contents

 ${}^{163} \\$ The Alternative Baking Soda Alternative

169 Bibliography

> 173 Index

Acknowledgments

Thanks, above all, to my family—Claudia, Marissa, and Adam.

A special debt of gratitude is owed John Pote, for giving me the idea, and Jerry Reen, for sharing his historical perspective.

Many thanks, as well, for the help and advice of the Hoffman family, Chris Lemmond, Tom Whitney, Dr. Wayne Sorenson, Steve Lajoie, Dr. William Jensen, and Jennifer Griffin.

transmarkeriamen to

Physical above all its mediants of the experience of the experienc

one say so, see to say it made to the first and the first of the first

ent to experie proposate (eith of loomen affine) in 1/2 of several and the 1/2 of several a

IntroductionBaking Soda, Naturally

That box of baking soda forgotten in your refrigerator? It has a story to tell. Your entire interest in baking soda may be how well it keeps your perishables from smelling like Tuesday's fish, but it is actually an amazing natural resource.

Baking soda is the common name for sodium bicarbonate, a natural salt that touches your life from the inside out. Sodium bicarbonate is, above all, essential to the functioning of the human body. It helps maintain the proper acid/alkaline balance of blood. It is the major vehicle of carbon dioxide transport from body tissue to the lungs. It is a primary component of the duodenal fluid that neutralizes stomach contents before they enter the intestinal tract. Sodium bicarbonate is also a component of saliva, where it helps to reduce the attack of orally generated acids on tooth enamel.

For the uses we weren't born with, sodium bicarbonate is available in virtually endless supply from the minerals trona and nahcolite, which supply the stuff in your refrigerator, and in briney lakes and lake sediments. Bicarbonate is also found in the world's oceans, where nature uses it to help stabilize the carbon dioxide content of the earth's atmosphere.

Baking soda as a household staple was actually invented by its consumers, not its producers. The use of baking soda to deodorize your refrigerator, dry-clean your dog, or clean everything from battery terminals to teeth was not contrived on Madison Avenue. The scores of popular baking soda applications featured in this book are really a testament to consumer ingenuity. Baking soda is a simple, cheap food ingredient for which generations of Americans have conceived some unusual, certainly unintended, but none-theless ingenious folk uses.

While these folk uses grew as an all-American phenomenon, most industrial uses are global. In addition to baked goods and mixes, these include animal feeds, fire extinguishers, textile processing, paper sizing, leather tanning, oil-well drilling muds, carpet cleaners, foam rubber, and paint strippers. Baking soda's unique attributes are even applied to controlling toxic metals in drinking water, improving waste treatment processes, and reducing harmful smokestack emissions.

Although it exists as an abundant natural resource, baking soda depends on sophisticated processing to meet the stringent standards of quality and purity mandated for its many uses. This beneficial amalgam of nature and technology may well be a worthy model for our times. In an age of acute environmental and ecological awareness, when chemicals are suspect and all things natural are preferred, baking soda has emerged as possibly the world's "greenest" chemical.

Baking Soda Rises

Baking soda in America began, naturally enough, with baking. Its foothold in American homes was based on its use as a leavening agent.

THE PEARLASH EVOLUTION

The discovery of baking soda began with potash, a crude potassium carbonate extracted from wood ashes. American colonists learned how to purify potash into the pearlash (a more concentrated potassium carbonate), which became an important ingredient to their booming soap- and glassmaking businesses. By the mid-eighteenth century, production of potash and pearlash had grown from a cottage industry to a major commercial enterprise. The colonies, with trees to burn, began exporting huge amounts of these carbonates to England's glass and soap factories as well.

It was during the 1760s that the use of pearlash in baking became popular. Bakers had been using tedious and difficult hand kneading as well as long-rising sourdough starters to leaven bread. Pearlash's high potassium carbonate content made it quite alkaline and was initially added as a natu-

Baking Soda Bonanza

ral counter to the sourness caused by the acids in sourdough. Bakers discovered, however, that besides sweetening the dough, pearlash accelerated its rising by liberating carbon dioxide gas bubbles as it reacted with the sourdough acids and baking heat. This ability of pearlash to create in minutes the leavening gases that required hours from the natural sourdough yeasts revolutionized baking.

The popularity of pearlash was fueled by two nearly concurrent developments in the United States. In 1796, Amelia Simmons published the first American cookbook, *American Cookery*, which featured several recipes requiring pearlash. At the same time, Oliver Evans was pioneering the fine grinding of wheat into lighter, airier flour. Almost at once, the home baker had pearlash, a growing body of instructions on how to use it, and increasingly available finer flours.

THE SODA ASH REVOLUTION

Although pearlash remained the premier industrial carbonate in America well into the nineteenth century, the American Revolution convinced the governments and industries of western Europe that their rapidly expanding need of American carbonates was politically and economically unwise. There was precious little European woodland left to sacrifice to wood ash, and the only natural alternatives were the limited supplies of crude carbonates produced from the ashes of seaweeds and plants. The situation became so alarming that the French Academy of Sciences offered a prize in 1783 for the best process for converting common salt (sodium chloride) to soda ash (sodium carbonate). Nico-

las LeBlanc won the prize in 1791 for his method of reacting salt, sulfuric acid, coal, and limestone. Soon soda ash plants proliferated in Europe. The now plentiful local supply of sodium carbonate replaced imported American potassium carbonates.

SALERATUS

The development of today's leavening bicarbonate from the industrial carbonates took different routes in Europe and America. European chemists bubbled carbon dioxide gas through solutions of sodium carbonate to form the less alkaline sodium bicarbonate. This chemical was dubbed saleratus, meaning "aerated salt." Saleratus was adopted by the medical community as a safe and effective treatment for acid stomach. By the 1830s, America's home bakers had discovered that the sodium bicarbonate imported for medical use was a superior (albeit expensive) leavening alternative to pearlash or the American version of saleratus. It released its carbon dioxide quickly in recipes and was less prone to bitter aftertastes.

American saleratus, potassium bicarbonate, was first made by Nathan Read of Salem, Massachusetts, in 1788. He suspended lumps of pearlash over the carbon dioxide—rich fumes of fermenting molasses. The dry pearlash absorbed the carbon dioxide, converting its potassium carbonate to potassium bicarbonate. By the early nineteenth century, brewers and distillers were making saleratus as a sideline in much the same way by taking advantage of the carbon dioxide released from their fermentation vats. American saleratus was less expensive than the imported variety, but it was not as pure and did not leaven as dependably.

Baking Soda Bonanza

America's bakers were ready for a saleratus that would work as well as the imported sodium bicarbonate but be as cheap as the domestic alternative. Two American entrepreneurs—one a doctor and the other a salesman—accepted the challenge and provided the sodium bicarbonate, which in time became the baking soda found in nearly every home.

THE DETERMINED DOCTOR

As America discovered the advantages of saleratus over pearlash, Dr. Austin Church, a Yale graduate, started experimenting with a new way to make sodium bicarbonate. On the basis of promising work begun in his kitchen in Ithaca, New York, Dr. Church decided to trade his medical practice for the commercial production of saleratus. In 1834 he uprooted his wife and children and moved to Rochester.

The process Dr. Church perfected in his Rochester factory started with the meticulous purification of English soda ash. This refined sodium carbonate was then spread thinly over canvas-covered wooden frames stacked in a sealed room. For three weeks, this room was filled with hot gases containing carbon dioxide from coal-fired ovens. By this dry carbonation method, the purified sodium carbonate was entirely converted to food-grade sodium bicarbonate.

It is not surprising that Dr. Church, with a physician's training in chemistry, saw opportunity and financial security in the commercial manufacture of a pure sodium bicarbonate. His choice of Rochester was equally well reasoned.

Following the opening of the Rochester and Lockport section of the Erie Canal in 1823, Rochester's proximity to the wheat fields of the Genesee Valley had propelled it to the status of the leading flour milling center of the United States. When the Church family arrived in 1834, Rochester had just recently received its city charter, Genesee Valley flour had earned worldwide fame, and the Rochester mills were turning out more than 300,000 barrels per year. Dr. Church's intent presumably was to produce saleratus in bulk for sale to the far-flung customers of the flour mills.

The bulk saleratus business allowed the Church family an adequate existence, but apparently not an especially prosperous one. After a brief return to doctoring in Oswego, in 1846 Dr. Church moved his family to New York City, where he and his entrepreneurial brother-in-law, John Dwight, founded John Dwight & Company.

DWIGHT'S SALERATUS

Dwight realized that the key to success, in addition to bulk sales to commercial bakers and drug companies, would be to build a consumer franchise by selling packages of saleratus through the retail trade. The busiest port of the nation proved itself an excellent headquarters; in their first year of operation, distinctively red-labeled "Dwight's Saleratus" was offered to New York's storekeepers in bags of one pound or less.

Within a few years, Dwight's Saleratus capitalized on its claims of superior quality and value. It captured the New York market and started expanding into every inhabited part of the United States and eventually into Canada. Its prime competition, especially in rural areas, came from the well-established imported saleratus sold loose in kegs. But the distinctive red-wrapped bags of Dwight's Saleratus became the baker's choice. By 1850, the American housewife could purchase Dwight's Saleratus from the general store for 4c/lb., quite an improvement over the \$1.25/lb. her mother had paid for the import in 1820.

Success, of course, bred competition, as other manufacturers saw there was money to be made in tapping this new market for low-cost, high-quality domestic bicarbonate. The 1860s witnessed new brands from small firms like Philadelphia's Burgin & Sons to the mighty Pennsylvania Salt Manufacturing Company. The most effective competition to emerge from the 1860s, however, was from Dr. Austin Church.

ARM & HAMMER

In 1865, the sixty-six-year-old Dr. Church retired from John Dwight & Company, and two years later helped his sons, James and Elihu Church—both successful businessmen in their own right—found Church & Company. Recognizing there was sufficient need in the rapidly expanding United States to accommodate a competitor with quality equal to Dwight's Saleratus, they constructed a factory in Greenpoint, Brooklyn, devoted to the manufacture and sale of sodium bicarbonate.

James had been a partner in the Vulcan Spice Mills, a Brooklyn mustard and spice business, from which he acquired the Arm & Hammer logo. This symbol represented the arm of Vulcan, Roman god of fire and metalworking, with hammer raised. While perhaps better suited to the spice trade, this trademark was distinctively recognizable and soon intimately associated with what became the country's best selling bicarb. Dwight's Saleratus eventually adopted a memorable trademark of its own, modeled on Lady Maud, a famous Jersey from the 1876 Philadelphia Centennial Exposition. Soon thereafter it became known as Dwight's Soda, Cow Brand, and in time simply Cow Brand Soda. Cow Brand and Arm & Hammer Bicarbonate of Soda became the dominant products in the chemical leavening business, but the rivalry was friendly and mutually beneficial.

In 1896, fifty years after John Dwight first sold Austin Church's saleratus, and nearly thirty years after their business interests had diverged, their descendants reunited the two leading bicarb producers into the Church & Dwight Company. To the merger Church & Company brought Arm & Hammer, the leading U.S. brand, while John Dwight & Company brought Cow Brand, the leading Canadian product. Although the two companies were now joined and the sodium bicarbonate came from a single source, the two brands were kept distinct to capitalize on the consumer loyalty each had earned over the years. This was rewarded with continued growth into the early decades of the twentieth century, when the term "baking soda" was first used. This name was most likely intended to differentiate pure sodium bicarbonate from the baking powders in which it was just one of several ingredients.

The power of brand loyalty was further demonstrated when Cow Brand Soda was discontinued in the United States after World War II. It was still the preferred brand in its birthplace, New York City, while Arm & Hammer dominated the rest of the country. Loyal New Yorkers stuck with

Baking Soda Bonanza

Cow Brand till the end, despite the manufacturers' efforts to ensure customers that both brands were one and the same baking soda. Cow Brand likewise remained the dominant baking soda in Canada until 1992, when it finally was discontinued in favor of Arm & Hammer.

BAKING AND BEYOND

The growth of baking soda into a household necessity during the second half of the nineteenth century was aided by the complex changes in a rapidly developing United States. Dwight's Saleratus was born at nearly the same time as the nationwide tax-supported public school system. A literate society invited the still-thriving publishing phenomenon of cookbooks. Baking recipes routinely required saleratus, and in 1860 Dwight's company started distributing free recipe booklets of its own. The 1860s also saw the spread of baking powders and yeast cake as convenient new leavening agents, but these were found suspect by the influential stalwarts of the U.S. health food movement of those days. The railroads became the backbone of the United States, transforming it into a world-class grain producer and fostering the rise of American-style mass merchandising. The full-service general store gave way to self-service neighborhood markets and finally to giant supermarkets. Packaging, trademarks, advertising, and distribution developed in such an amazingly complementary fashion that companies like Dwight's and Church's, with distinctive packaging and staunch consumer loyalty, established themselves securely. Baking soda remained the preferred home leaven for nearly everything but bread into the twentieth century.

The versatility, low cost, and high quality of baking soda led consumers to discover a wide variety of uses beyond leavening nearly from the start and on into the early part of this century, while its use in home baking was still strong. As baking in the home eventually declined, these folk uses of baking soda grew and filled the void, and lately have been supplemented by a variety of commercial and industrial applications. The folk uses are perhaps unique in that in many cases they have drawn the support of the scientific community. Uses based on tradition have been sustained on effectiveness. Some folk uses have even developed into amazing commercial successes, like the two examples that follow.

NOT JUST CHICKEN FEED

Today, food companies, not individuals, use most of the baking soda produced for leavening, but the major consumers of baking soda are cattle, not people. High-tech ranching depends upon a use of baking soda developed by farmers decades before its scientific and economic advantages were documented.

Today's dairy cow is bred to be a milk factory, with top producers easily exceeding twelve gallons per day. Genetics determines the maximum output possible, but energy input dictates actual results. Energy comes from food, which is broken down by bacteria in the rumen (the partially digested food) and ultimately converted to milk. The digesting bacteria function at peak efficiency only when the rumen is just slightly acidic.

Dairy cows eat a range of feeds, from low-energy, highfiber food like dry hay and dry grass, to high energy grains. Maximum milk production and milk fat content depend upon a substantial level of the high-energy grain in the cow's diet. But high-grain, low-fiber feeds require less chewing, which leads to a decrease in saliva production. Since saliva contains naturally occurring sodium bicarbonate, less chewing makes the rumen more acidic. The more acidic the rumen, the less efficient its digesting bacteria become. When the bacteria become seriously inhibited, digestion slows, feed intake decreases, and milk production drops. Acid stomach in cows is corrected by supplementing saliva sodium bicarbonate with baking soda blended right into the grain. This balances rumen acidity, and the cow maintains optimum output.

A similar situation exists with beef cattle. To prepare for market, they eat a high-energy, low-fiber diet to maximize weight gain. Since this gain can exceed one hundred pounds per month, and the rancher is paid per pound, the efficiency of food conversion is very important. Like the dairy cow, the steer produces less bicarbonate-containing saliva with the easier-to-chew grain. As the rumen becomes more acidic, feed intake, feed efficiency, and weight gain drop. Sodium bicarbonate in the feed prevents this, allowing the steer to gain weight faster and be ready for market sooner.

The success of sodium bicarbonate supplementation of high-energy cattle feed has made this its single largest use worldwide. This success has also attracted the attention of other livestock breeders, who are adopting the use of sodium bicarbonate to maximize the health and economic value of their animals. Of course, baking soda is not limited to improving our meat and milk supply. In chicken feeds, baking soda promotes tougher eggshells, so that breakage between the henhouse and your house is minimized.

Animals may eat more baking soda than we do, but we're taking up the slack as a new type of baking soda "consumer." People kept their teeth clean and healthy with baking soda for more than one hundred years before scientists decided that this was a good idea. Now we use more baking soda on our teeth than in our muffins.

DENTAL CARE

Sodium bicarbonate is the only product in use today that was on the original list of products accepted by the American Dental Association in 1931. It cleans and polishes, of course, but in the process it also reduces plaque and tartar buildup, deodorizes the mouth, and leaves a particularly clean feeling. Its popularity was hampered, nevertheless, by the inconvenient powder form, the salty taste, and the lack of cavity-fighting fluoride. Church and Dwight corrected this in 1988 by offering a minty baking soda toothpaste with fluoride. Their nationwide campaign proved so successful that today baking soda toothpastes are offered by every major dentifrice producer and many smaller ones.

After six generations of baking soda's safe and effective use in dental care, scientists proved what grandma knew all along. Baking soda is safe and nonirritating to all oral tissues—less than startling news for a natural component of saliva. Baking soda reduces stains and plaque through its gentle polishing action. Tests have shown that toothpastes with high levels (60 to 65 percent) of baking soda clean as well as toothpastes with conventional abrasives, while showing much less abrasion. The mild alkalinity of baking soda can also react with and remove substances that dull or stain

Baking Soda Bonanza

teeth. More importantly, baking soda reduces decay by neutralizing plaque acids. By controlling plaque, it controls tartar. Scientists even have documented the ability of the leading baking soda toothpaste to eliminate bad breath from subjects fed cheeseburgers with onion and garlic. Not content, apparently, that all bases were covered, a follow-up study was conducted on subjects who each drank a can of warm beer and then smoked two unfiltered cigarettes. Baking soda prevailed.

HOME CARE

Cattle feed and dentifrice are just two of the applications that originated with baking soda users. We can thank the many generations of clever and inventive bicarb boosters for the three hundred or so folk uses that follow as well. They have not all inspired equally successful enterprises, but they have provided a valuable, safe, and effective alternative to commercial chemical formulations in and around our homes.

The Household Alternative

The blend of American ingenuity and Yankee frugality during the first century or so of its commercial existence produced an incredible range of uses for baking soda around the home. Baking soda was, above all, a pure and inexpensive staple and an old standby for baking. Until fairly recently, "make do" was the ethic spurring application of baking soda to tasks undreamed by Austin Church and John Dwight. There may have been a name brand scouring powder, tooth powder, kitchen cleaner, or mouthwash at the local grocery store, but the clever and thrifty homemaker could make do with the ever-reliable baking soda. More often than not, making do provided fine results. And, in true American fashion, making do was seen as an emblem of resourcefulness rather than a reflection of low economic status. Homemakers started writing to the bicarb producers, and later to newspaper and magazine columnists, with their latest brainstorms on how to use baking soda for nearly everything but baking.

In the past two decades, environmental concerns have lead to a shift in focus in baking soda use. The smart and economical alternative to scores of specialized powders and potions for home and personal care has become the safe and natural alternative as well. Baking soda's versatil-

Baking Soda Bonanza

ity, purity, safety, and simplicity have recommended it to those who prefer to avoid organic solvents, harsh chemicals and suspect chemical additives in the products used in their homes.

Home use continues to grow because regardless of the user's motivation, baking soda is effective. It's used because it works. Despite the fact that virtually all of the folk uses of baking soda were, by definition, developed and promulgated by users in the home, there are sound scientific reasons why baking soda is so effective in so many different applications.

BAKING SODA BUFFERS

The basis of most of baking soda's uses is its fundamental chemical nature. Even though a baking soda solution is weakly basic, it acts as a chemical buffer when acids or bases are added. It tries to bring them to its own nearly neutral state. In this way, baking soda can act as either an acid or base itself. In the presence of acids it acts as a neutralizing base. In the presence of bases it acts as a neutralizing acid. This dual nature accounts for many of baking soda's uses. Unquestionably, the most important use to which we all put the buffering properties of baking soda is the one we are born with—the bicarbonate ion is the naturally occurring component of blood that maintains its delicate acid/base balance.

BAKING SODA CLEANS

Baking soda is a triple-threat cleaner, supplying detergency, gentle abrasion, and effervescence. Its mildly alkaline (basic) nature is the basis of its gentle cleansing action. Most dirt and grease contain fatty acids, which react with baking soda to form a soap. This soap in turn works to remove the rest of the dirt or grease components. While stronger alkalis, like lye or lye-based products, can produce more cleaning power, they are generally toxic or irritating and not nearly as safe as baking soda on soiled surfaces or the user's hands.

Baking soda provides gentle abrasion in paste form, or dry on a damp sponge or toothbrush. The dissolved portion provides detergency for the soil lifted by the soft undissolved crystals. These crystals are softer than nearly any surface and break down readily in use, actually providing more polishing than abrasion. Baking soda cannot scratch most household surfaces, and is added in the home to soaps and detergents to enhance their cleaning power. Besides reacting with soils to form cleansing soaps and physically lifting soil particles by gentle abrasion, baking soda can produce effervescent bubbles that lift dirt from most surfaces. All that's needed is baking soda, water, and a common kitchen acid like vinegar.

Baking soda's unique combination of cleaning effects has made it the safe cleaning alternative around the home for nearly everything from stained kitchen sinks, to mildewed shower tile, to teeth.

BAKING SODA DEODORIZES

Most deodorizers work either as a perfume (like a room deodorizer) to mask odors, or an absorbent (like charcoal or coffee grounds) to physically entrap odors. Perfumes do not eliminate unpleasant odors; they just overpower them with a more acceptable scent. Absorbents eventually come to equilibrium with the air and release some of the odor originally contained. Baking soda neutralizes odors in the air. Many objectionable odors are either strongly acidic or strongly basic. Baking soda deodorizes by chemically reacting with acidic odors, like sour milk, or basic odors, like spoiled fish, and irreversibly converting them to a cleaner state.

Baking soda works best in a confined and somewhat humid space, such as a refrigerator, car trunk, or closet. Its deodorizing efficiency depends on how much odor it has to deal with and how long it has to work. The longer air is in contact with baking soda, the more odor neutralization takes place. In the refrigerator, an open box of baking soda will be effective for about three months.

Baking soda deodorizes in solution much as it does in the air. Solutions used as a mouthwash, a cutting board cleaner or a hand cleaner will neutralize, for example, acidic onion and garlic odors and basic fish odors.

BAKING SODA EXTINGUISHES FIRES

In the presence of high heat, baking soda decomposes to sodium carbonate (soda ash), water, and carbon dioxide. It can be used on electrical fires in equipment and wiring and flammable liquid fires involving grease, gasoline, oils, and solvents. It is not recommended for fires involving ordinary combustibles, like paper, cloth, wood, and plastics, because they can reignite. Water is the most effective extinguisher for these. Commercial dry chemical, foam, and soda/water fire extinguishers all contain baking soda.

BAKING SODA WORKS

Baking soda is used most often in one of three basic forms: dry—sprinkled baking soda straight from the box, as a paste—three parts baking soda combined with one part water, or as a solution—four tablespoons baking soda dissolved in one quart of water.

The recipes that follow call for baking soda in one or more of these forms as well as in variations combining baking soda with other household ingredients.

These recipes are safe for their intended uses, but use your common sense. If there is any question about the colorfastness or delicacy of a soiled surface, try the formula on a small, inconspicuous part first. Use every ingredient, even everyday kitchen items like salt and vinegar, carefully to avoid irritation to eyes and skin. (When cleaning with any composition, whether as innocuous as baking soda or aggressive as a heavy-duty commercial toilet bowl cleaner, it is good practice to wear skin and eye protection.) Keep all chemicals out of the reach of children.

Test personal care formulas on a small patch of skin, the inside of the forearm for instance, if you are concerned about sensitization or allergic reaction. Sterilize or at least meticulously wash all containers and mixing equipment for

storing personal care formulas, especially those used near the eyes. If you have any reservations about using a formula in the eyes or on broken skin, seek the advice of a health care professional.

PERSONAL CARE

Baking soda contains sodium. If you suffer from hypertension or are on a salt-restricted diet, consult your health care professional before taking baking soda internally. While baking soda is a natural choice for neutralizing stomach acids, it is not a remedy for other types of stomach problems such as nausea, stomach ache, gas pains, abdominal cramps, or stomach distention (bloating) caused by overeating or overdrinking.

Antacid

- 1. Take a level ½ teaspoon dissolved in 4 ounces of water.
- 2. Dissolve 1 tablespoon baking soda and 1 teaspoon sugar in 1 cup water; add a few drops of peppermint oil to taste. Bottle, and store in the refrigerator. Take 1 to 2 tablespoons as needed.

Athlete's Goot Treatment

Rub the affected area with a paste of baking soda and warm water. Rinse, dry thoroughly, and apply an over-the-counter athlete's foot treatment. Prevent a recurrence with a light dusting of baking soda on the feet every day to reduce mois-

The Household Alternative

ture from perspiration. A periodic foot soak in baking soda solution will keep feet extra-clean as well.

Bath Salts

 Dissolve ½ cup baking soda in the bath water to neutralize body odors, and to clean away dirt, perspiration, and the cares of the day.

2. Combine cleaning and moisturizing by adding $\frac{1}{2}$ cup baking soda plus 1 cup baby oil to the bath wa-

ter.

3. Make a container of bubbling bath salts by combining 2½ cups baking soda, 2 cups cream of tartar, and ½ cup cornstarch. Use ¼ cup per bathful.

4. For body soreness, mix together a container of 2 cups baking soda, 1 cup Epsom salts, and ½ cup salt. Use ½ cup per bathful.

Blackhead Buster

Apply a paste of 1 tablespoon baking soda and 1 tablespoon tepid water. Rub gently for 2 minutes, then rinse with very warm water. Do not squeeze.

Burn Soothers

 For minor burns, including sunburn, soak in a tepid bath containing 1 cup baking soda.

2. Take a sponge bath with a solution of $\frac{1}{4}$ cup baking

soda in 1 quart warm water.

3. For small minor burns use a wet compress over a

Baking Soda Bonanza

paste of 3 tablespoons baking soda and 1 tablespoon water or witch hazel.

4. For sunburn blisters, use a sterile dressing soaked in a solution of 1 tablespoon baking soda in 1 cup water.

Canker Sore Relief

To help relieve canker sore pain, swish a solution of 1 teaspoon baking soda in 4 ounces warm water gently through your mouth.

Chlorine Neutralizing Hair Rinse

Neutralize the effects of pool water chlorine with a rinse solution of 1 teaspoon baking soda in 1 pint water.

Contact Lense Storage Fluid

Store hard contact lenses in a solution of ¼ teaspoon baking soda and ¼ teaspoon salt in 1 cup sterile water. Mix in a sterile container until clear. Pour the solution through a paper coffee filter and store in a sterile dropper bottle.

Cuticle Softener

Soften cuticles by scrubbing with a wet nailbrush dipped into baking soda. Rinse and pat dry.

Dental Device Cleaner

- Keep braces clean by brushing with baking soda on a wet toothbrush.
- 2. Keep retainers clean by soaking in a solution of 1 tablespoon baking soda in 1 cup water.

Denture Cleaner

- 1. Soak dentures in a solution of 1 tablespoon baking soda in 1 cup water.
- Scrub dentures with baking soda on a wet toothbrush.

Deodorant

Dust some baking soda under your arms to absorb perspiration, neutralize odors, and avoid stained clothing.

Earwax Softener

For buildup of hardened earwax, at bedtime try a few drops of a solution of $\frac{1}{4}$ teaspoon baking soda and $\frac{1}{2}$ cup glycerin in 1 cup sterile water. Mix in a sterile container until clear and store in a sterile dropper bottle.

Elbow Scrub

Scrub grimy elbows with baking soda sprinkled on a damp washcloth. Rinse and dry.

Eye Soother

Apply a solution of scant 1 teaspoon baking soda in 1 cup sterile water to red or irritated eyes using a sterile eyedropper or an eyewash cup. Always use fresh solution.

Jacial Scrub

 Remove dirt, grime, and makeup residues by gently scrubbing with a paste of 3 tablespoons baking soda and 1 tablespoon water. Use on wet face after normal washing. Rinse and pat dry.

2. For an extra-moisturizing scrub, grind 2 table-spoons baking soda and 1 teaspoon oatmeal to a fine powder in a food mill or food processor. Make a paste and use as above.

Goot Soak

For calluses, tired feet, and athlete's foot itching, soak feet for 10 minutes in a solution of $\frac{1}{2}$ cup baking soda in 2 quarts warm water.

Goot Softener

Soften heels and calluses by rubbing with a paste of 3 tablespoons baking soda and 1 tablespoon water. Follow with a foot soak.

Gargle

- 1. Gargle with a solution of 1 teaspoon baking soda in 4 ounces water.
- 2. For a mild sore throat, try gargling with a solution of ½ teaspoon baking soda and 2 crushed aspirins (regular strength) in 4 ounces water.

Insect Bite and Sting Relief

Quickly apply a paste of 1 tablespoon baking soda and 1 teaspoon water, witch hazel, or clear ammonia. Cover with a damp dressing.

Knee Scrub

Scrub grimy knees with baking soda sprinkled on a damp washcloth. Rinse and dry.

Leg Shave

For shaving legs with a safety razor, use a solution of 1 table-spoon baking soda in 1 cup water.

Mouthwash

For a fresh-feeling mouth, rinse with a solution of 1 teaspoon baking soda in a half glass of water.

Nail Cleaner

Clean toenails and fingernails by scrubbing with a wet nail brush dipped into baking soda.

Poison Duy Relief

Relieve poison ivy itch with a wet compress on a paste of 1 tablespoon baking soda and 1 teaspoon water or witch hazel.

Rash Soother

 For minor rashes, soak in a tepid bath containing 1 cup baking soda.

Take a sponge bath with a solution of 4 tablespoons baking soda in 1 quart warm water.

3. For small areas use a wet compress on a paste of 1 tablespoon baking soda and 1 teaspoon water or witch hazel.

Razor Burn Preventer

Minimize razor burn irritation with a solution of 1 tablespoon baking soda in 1 cup water as a preshave or aftershave splash.

Sap Remover

Remove sticky tree sap from hair and skin by wetting and rubbing briskly with baking soda. Rinse well and repeat if necessary.

Shampoo Helper

 To remove conditioner buildup, once a week massage baking soda into wet hair. Rinse thoroughly, then shampoo and condition as usual.

2. For dandruff or for more severe conditioner buildup, wet hair and massage a handful of baking soda into hair and scalp. Rinse thoroughly and air-dry or blow dry at the coolest setting. Alternate daily washings with baking soda and baby shampoo until hair returns to a normal healthy state.

Sponge Bath

Wash away dirt, odors, and perspiration with a solution of $\frac{1}{2}$ cup baking soda in 2 quarts warm water.

Teeth Cleaners

- 1. All you need to clean and polish teeth is a little baking soda on a wet toothbrush.
- For a sweeter tooth cleaner preblend 1 cup baking soda with ½ to 1 teaspoon artificial sweetener.
- 3. For extra whitening try a paste of 1 tablespoon baking soda and 1 teaspoon hydrogen peroxide.
- 4. If you use a Waterpik, dissolve 1 teaspoon baking soda in the water for extra-clean teeth and gums.

Toothbrush Cleaner

Clean toothbrush bristles by soaking overnight in a solution of 1 teaspoon baking soda in $\frac{1}{2}$ cup water.

BABY AND CHILD CARE

Baby Movers Cleaner

Clean car seats, strollers, carriages, and walkers with baking soda sprinkled on a damp sponge. Rinse well and dry.

Bed-Wetting Response

 When your child wets the bed, blot the mattress with a towel and sprinkle the area with baking soda. Let it dry thoroughly and then vacuum.

Sprinkle the wet bedclothes and sheets with baking soda to control urine odor and to ensure good results on laundering.

Bottle Cleaner

Fill baby bottles that smell of sour milk or juice with 2 tablespoons baking soda and hot water. Shake briefly and let soak overnight. Rinse and wash as usual.

Clothing Detox

Remove unwanted chemical finishes on new baby clothes by washing in soap powder plus ½ cup baking soda.

Clothing Refresher

1. Freshen clean baby clothes that have been in storage by briefly soaking in a solution of ¼ cup baking soda in 2 quarts water. Rinse and air dry.

The Household Alternative

 Add ½ cup baking soda to baby's laundry for fresher smelling babywear.

Comb and Brush Cleaner

Gently clean baby's combs and hairbrushes by swishing in a solution of 1 teaspoon baking soda in 1 quart water. Rinse well and air dry.

Cradle Cap Treatment

Gently apply a paste of 1 tablespoon baking soda and 1 teaspoon water to the affected area just before bath time. Leave on for about 1 minute and then rinse thoroughly.

Diaper Pail Relief

- With each deposit to the diaper pail, add a liberal dose of baking soda to control odors until emptying.
- Clean plastic diaper pails that have absorbed odors by adding 1 cup baking soda and then filling with warm water. Let this solution work for a couple of hours, then rinse and air dry.

Laundry Presoak

Presoak items needing extra cleaning muscle, like dirty cloth diapers, in a solution of $\frac{1}{2}$ cup baking soda in 1 gallon water.

Marker Cleanup

- Clean children's art marker from washable surfaces with baking soda sprinkled on a damp sponge. Rinse and dry.
- 2. Clean art marker from children with baking soda sprinkled on a wet washcloth.

Nursery Cleaner

Clean plastic nursery items like changing pads, crib bumpers, mattress covers, baby's bathtub, toys, and rattles, plus washable crib, changing table, and bassinette surfaces with a solution of 1 tablespoon baking soda in 1 cup water. Rinse and dry.

Nursery Scrub

For heavy-duty cleaning of plastic nursery items like changing pads, crib bumpers, mattress covers, baby's bathtub, toys, and rattles, plus washable crib, changing table, and bassinette surfaces, scrub with a little baking soda on a damp sponge. Rinse thoroughly and air dry.

Rash Soother

- 1. Give baby a sponge bath with a solution of 1 tablespoon baking soda in 1 quart water to take the sting out of mild diaper rash and prickly heat. Pat dry gently with a soft towel.
- 2. Use a solution of 1 tablespoon baking soda in 1 quart water as a bath soak to soothe mild diaper rash.

Rug Cleaner

Clean spills or accidents on nursery rugs or carpeting with club soda. Let dry thoroughly overnight. Then sprinkle baking soda on the affected area and let sit for 15 minutes before vacuuming it up.

Scribble Scrubber

Remove crayon marks from washable walls, floors, tables, chairs, cribs, bureaus, high chairs, car seats, carriages, strollers, and toys by gentle scrubbing with baking soda on a damp sponge or nylon scrubber. Rinse well and dry.

Shoe Cleaner

Renew white baby shoes with baking soda sprinkled on a damp sponge. Rinse with a clean damp sponge, dry, and buff lightly. Polish if necessary.

Spatter Spotter

Use a paste of 3 tablespoons baking soda and 1 tablespoon water to pretreat milk, food, and spit-up stains on clothes and bedding. This also prevents sour odors.

Stuffed Toy Cleaner

 Place nonwashable stuffed toys in a large bag, add ½ cup of baking soda, close the bag and shake vigorously. Remove from the bag and shake off as much baking soda as possible. Remove the rest with a brush.

Baking Soda Bonanza

2. Surface-clean vinyl-covered stuffed toys with a solution of 1 tablespoon baking soda in 1 cup water. Remove stains with a little baking soda on a damp sponge.

Stuffy Nose Relief

Mix 1 cup sterile water with ¼ teaspoon baking soda and ½ teaspoon salt in a clean container until clear. Pour the solution through a paper coffee filter and store in a sterile dropper bottle. Add a drop or two to each nostril for temporary relief of stuffiness.

Vomit Control

If you cannot attend to vomit immediately, cover it with baking soda to control the odor.

PET CARE

Accident Deodorizer

Pet accidents and vomit on carpeting and upholstery leave a lingering odor for the animal. Thoroughly clean the spot (check for colorfastness). When completely dry, sprinkle liberally with baking soda. Let sit for 15 minutes and then vacuum.

Bedding Deodorant

To clean and deodorize dry colorfast pet bedding, sprinkle liberally with baking soda. Let sit for 15 minutes and vacuum thoroughly.

Cage Cleaners

 Clean and deodorize cages for birds, hamsters, mice, guinea pigs, rabbits, and other pets with baking soda sprinkled on a damp sponge. Rinse well and dry. Do this when the pet is elsewhere, as when you change papers or litter.

Sprinkle baking soda on the bottom of pet cages before adding paper or litter to control odors between cleanings.

Dental Care

Brush Fido's teeth and control dog breath with a toothbrush and a solution of 1 tablespoon baking soda in 1 cup water.

Dish Cleaner

- Periodically scrub your pet's food dish and water bowl with baking soda sprinkled on a damp sponge. Rinse and dry.
- 2. Deodorize plastic food dishes by filling with a solution of 4 tablespoons baking soda in 1 quart water and soaking overnight. Make sure the dish is out of your pet's reach while soaking. After soaking, wash with a mild detergent, rinse well, and dry.

Ear Cleaner

Wash itchy pet ears with a solution of 1 tablespoon baking soda in 1 cup water.

Eye Cleaner

Carefully clean around runny eyes with a cotton swab moistened in a solution of $\frac{1}{2}$ teaspoon baking soda in 4 ounces water.

Fur Cleaner

- Gently massage a small amount of baking soda into your dog's coat and then brush out. This will reduce odors between baths.
- 2. Remove loose hairs (hairball material) from your cat's coat by gently stroking with a sponge dampened with a solution of 1 tablespoon baking soda in 1 cup warm water.

Litter Box Deodorant

- 1. To help control odors, sprinkle baking soda on the bottom of the litter box before adding litter. Use 1 cup of baking soda for each 3 pounds of litter.
- To control the odor of used litter that you can't dispose of promptly, cover with baking soda.

Puppy Training Aid

If you use the newspaper approach to puppy housebreaking, minimize odor by sprinkling the wet newspapers liberally with baking soda before discarding.

KITCHEN

Appliance and Sink Bleach

Renew yellowing white porcelain sinks and white enameled metal appliances by sponging on a solution of ½ cup baking soda and ½ cup chlorine bleach in 1 quart warm water. Let sit for 15 minutes, then rinse well and dry. Use gloves and keep this solution away from children, pets, and all bleachable surfaces. Do not use on colored appliances or colored sinks.

Burner Catch Pan Cleaner

One of the best ways to remove burned-on spills from cast iron, stainless steel, and enamel burner catch pans is to put them in a nonaluminum pan, cover the charred area liberally with baking soda, add enough water to cover everything, and boil for a few minutes. Remove from the heat and let soak as the water cools. Remove the softened residue with baking soda on a steel wool pad or nylon scrubber.

Burned Stuck Good Releaser

To soften food stuck or burned onto all types of cookware (except aluminum), douse with baking soda. Then cover with hot or boiling water and let soak for about 10 minutes, longer if necessary. For extra-tough jobs, gently boil the baking soda and water right in the cookware. Once the residue is softened remove it with baking soda and a wet nylon scrubber.

Chair and Table Leg Cleaner

Remove dirt, grime, and spatter from the metal legs of kitchen chairs and tables with a scrub of baking soda on a damp sponge. Rinse well.

Cleanser

A damp sponge and a liberal sprinkle of baking soda or equal parts baking soda and salt can replace store-bought abrasive cleansers for most scouring jobs. You can even use baking soda safely on many surfaces that abrasive cleansers will scratch, like plastics and fiberglass.

Clean-ups Cleaner

Soak kitchen sponges, nylon scrubbers, and scrub brushes overnight in a solution of ½ cup baking soda in 1 quart water for a thorough cleaning and degreasing.

Cloth Seat Cleaner

- 1. Clean fresh stains on colorfast cloth chair seats and backs with a paste of 3 tablespoons baking soda and 1 tablespoon water. Rub the paste into the stain, let dry, and then brush or vacuum away.
- 2. Absorb fresh greasy stains on colorfast cloth chair seats and backs with a blend of 1 teaspoon baking soda and 1 teaspoon salt. Sprinkle the powder on the stain, brush lightly, leave for a few hours, and vacuum.

Coffee Pot Cleaner

- Wash glass, enamel, and stainless steel coffee pots with a solution of 4 tablespoons baking soda in 1 quart water.
- 2. Clean heavily stained pots by scrubbing with a paste of 3 tablespoons baking soda and 1 tablespoon water, or boiling a solution of ½ cup baking soda and 2 quarts water.

Do not clean aluminum pots with hot baking soda solutions.

Coffee | Tea Stains

- Clean coffee- or tea-stained plastic ware, china, cutting boards, and countertops by scouring with baking soda and a damp sponge.
- 2. For resistant stains on plastic laminate counters, cover with lemon juice, let soak for 45 minutes, then sprinkle on baking soda and rub with a damp sponge. Rinse well.

Cruet Cleaner

When oil cruets resist simple washing, add 1 tablespoon baking soda and fill with hot water. Shake to dissolve the baking soda and let soak for at least 1 hour. Empty and wash.

Crystal Sparkler

Soak crystal and cut-glass stemware and serving pieces briefly in a solution of $\frac{1}{2}$ cup baking soda in 2 quarts water to remove spots and return the sparkle. Rinse thoroughly and dry.

Cutting Board Deodorizer

Deodorize wood cutting boards of fish, onion, or garlic odors by scrubbing with a paste of 3 tablespoons baking soda and 1 tablespoon water. Leave the paste on for 10 to 15 minutes. Rinse well and dry.

Degreaser

- Remove dried-on grease spots from stovetops and backsplashes with baking soda sprinkled on a damp nylon scrubber. Rinse well and dry.
- 2. Remove greasy films from appliances and washable cabinets with a solution of ½ cup ammonia, 2 table-spoons baking soda, and ¼ cup white vinegar in 2 quarts water. Apply with a sponge, rinse, and dry. Use rubber gloves and good ventilation.
- 3. Degrease the metal mesh filter from your stove hood by putting it in a stoppered sink, covering it

with baking soda, and adding hot water until it is just submerged. Let it sit for at least 15 minutes, longer if it's really greasy. Then add more hot water and a little dishwashing liquid, swish the filter briefly, and rinse. Let air-dry.

Dishwasher Cleaners

- Remove stains and odors from the insides of automatic dishwashers with baking soda sprinkled on a damp sponge. Rinse well and dry.
- Wash the door gaskets on automatic dishwashers on a routine basis to keep them clean and mildewfree.

Dishwasher Deodorizer

Sprinkle some baking soda into the automatic dishwasher between washings to control odors.

Dishwashing Detergent Booster

- For extra grease-cutting action for hand dishwashing add 2 tablespoons baking soda to hot water in the dishpan along with the detergent.
- Remove stuck-on food by scouring with baking soda on a nylon scrubber.

Drain Cleaners

1. Mix a container of 1 pound baking soda and 1 pound salt. Store tightly covered. Once a week pour ½ cup

Baking Soda Bonanza

down the drain followed by 1 cup boiling water. Allow to sit for an hour or so, then flush with hot tap water.

- 2. Mix a container of 1 pound baking soda, 1 pound salt, and ½ cup cream of tartar. Once a week pour ½ cup down the drain followed by 1 cup boiling water. Allow to sit for 15 minutes, then flush with hot tap water.
- 3. Pour $\frac{1}{2}$ cup baking soda down the drain followed by $\frac{1}{2}$ cup vinegar. Let sit for about 2 hours. Flush with hot tap water.

Drip Coffee Maker Cleaner

- 1. Run the coffee maker through one cycle using a solution of ½ cup baking soda in 2 quarts water. Follow with two cycles of plain fresh water. If the coffee maker has an aluminum basket, remove it before this process.
- Save a little of the above baking soda solution when first made to sponge-clean exterior plastic surfaces. Rinse and dry.

Drip Tray Cleaner

- Periodically scrub your refrigerator drip tray with baking soda on a damp sponge to control mold and musty odors. After scrubbing, rinse well and dry.
- 2. If mold already has the upper hand, scour with a paste of 3 tablespoons baking soda and 1 tablespoon chlorine bleach. Wear gloves. After cleaning, rinse well and dry.

Flatware Cleaner

Clean tarnished or spotted silver and stainless steel flatware with baking soda sprinkled on a wet sponge. Rinse well and buff dry.

Good Container Deodoriger

- 1. Food or beverage odors absorbed by glass and plastic storage containers can be eliminated by adding 2 to 4 tablespoons baking soda to the washed container and filling with hot water. Cover, shake, and soak at least 2 hours, longer for strong odors. Rinse well and wash as usual.
- 2. Add some baking soda before closing and storing seasonal items, like picnic jugs and ice chests, to keep them smelling clean.

Good Processor Blade Cleaner

To thoroughly clean the crevices and crannies of your food processor blade assembly, half-fill the clean processor container with water, add 2 tablespoons baking soda, cover, and run briefly at medium speed. Then add a few drops of dishwashing liquid and run at low speed for a few seconds. Empty the container and wash as usual.

Gruit Cleaner

Clean wax and pesticide residues from fruits like apples, plums, nectarines, and pears with a paste of 3 tablespoons baking soda and 1 tablespoon water. Waxy coatings may

Baking Soda Bonanza

need a few drops of dishwashing liquid as well. Rinse well and dry.

Garbage Disposal Cleaner

Keep the garbage disposal ungunked by running warm tap water, then pouring in 1 cup baking soda with the disposal on. Keep the water running briefly after all the baking soda is gone.

Garbage Pail Care

- Add baking soda to the kitchen garbage pail as needed to control odors until emptying.
- 2. Clean plastic garbage pails that have absorbed odors by adding 1 cup baking soda and then filling with warm water. Let this solution work for a couple of hours, then rinse and air-dry.

Hand Deodorizer

Eliminate onion, garlic, or fish smell by wetting your hands and scrubbing with baking soda. Rinse well and dry.

High Chair Cleaner

- 1. Safely clean baby's high chair after feedings by sponging with a solution of 1 tablespoon baking soda in 1 cup water. Rinse well.
- 2. Remove any dried-on food with a scrub of baking soda on a damp sponge. Rinse well.

Microwave Oven Cleaners

 Clean dried-on spatter from the inside of your microwave oven with a little baking soda sprinkled on a damp sponge. Rinse and dry.

For a general cleaning inside and out, use a sponge and a solution of 1 tablespoon baking soda in 1 cup

water. Rinse well and dry.

Nonstick Cookware Cleaner

Clean stained nonstick cookware by combining 1 cup water, 2 tablespoons baking soda, and ½ cup white vinegar. Boil for 10 minutes with the stove hood fan on. Wash as usual.

Oven Cleaner

Do not use any type of cleaner on a self-cleaning or continuous clean oven. Clean a standard oven when cold with a paste of ½ cup baking soda (or ¼ cup baking soda and ¼ cup salt) and ¼ cup water and a steel wool pad. Do not get any type of cleaner on the heating elements of electric ovens because they can corrode when hot and short out.

Oven Glass Cleaners

- To remove the grease and spatter burned onto the glass in oven and toaster oven doors, scrub with baking soda on a damp sponge. Rinse well and dry.
- 2. For extra-tough jobs, try scrubbing with a paste of 3 tablespoons baking soda and 1 tablespoon ammo-

Baking Soda Bonanza

nia (gloves and ventilation required). Rinse well and dry.

Plastic Container Cleaner

To remove greasy films from food or sticky films from long cabinet storage, clean plastic containers by wetting and then gently scrubbing with baking soda sprinkled on a damp sponge. Rinse well.

Refrigerator/Freezer Cleaners

 Remove stains, films, and odors from the insides of refrigerators and freezers with baking soda sprinkled on a damp sponge. Rinse well and dry.

Wash the door gaskets on refrigerators and freezers on a routine basis to keep them clean and mildewfree.

Refrigerator/Greezer Deodorizer

Open two boxes of baking soda and label them with a date 3 months away. Place one in the refrigerator and one in the freezer. Replace on the indicated date. Pour the used boxes in the garbage to deodorize or down the drain or garbage disposal to clean and remove odors.

Rubber Glove Glide

Sprinkle a little baking soda into rubber kitchen gloves to make them easier to put on.

Scuff Mark Remover

Remove black heel marks on washable kitchen flooring by scrubbing with baking soda on a damp sponge.

Stainless Steel Cleaner

Clean marked or spotted stainless steel serving trays, sinks, appliances, and bowls with baking soda sprinkled on a wet sponge. Rinse well and dry.

Tabletop Scrub

- Remove stains from glass or plastic laminate tabletops with baking soda sprinkled on a damp sponge. Rinse well and dry.
- 2. For resistant stains or light burn marks on plastic laminate tops, cover with lemon juice for about ½ hour and then scrub with baking soda on a damp sponge. Rinse well and dry.

Vinyl Seat Wash

Safely clean the vinyl on kitchen chairs by sponging with a solution of 1 tablespoon baking soda in 1 cup water. Rinse well and dry.

Waffle Iron Cleaner

Remove residues from the crevices of waffle iron grids by scrubbing with baking soda on a wet toothbrush. Rinse well, dry thoroughly, and re-season.

BATHROOM

Cabinet/Closet Deodorizer

Put an open box of baking soda in the bathroom closet and in the vanity cabinet to control odors. Every 3 months empty 1 box down the toilet and the other down the sink, and replace.

Drain Cleaner

Pour 1 cup baking soda, 1 cup salt, and ½ cup white vinegar into the sink, tub, or shower drain. Let sit for about 15 minutes. Flush with hot tap water. Use this also as a combination toilet bowl and toilet drain cleaner.

Grooming Accessories Cleaner

Clean combs, hairbrushes, plastic curlers, loofah sponges, and makeup applicators by soaking in a solution of 4 tablespoons baking soda in 1 quart water.

Grout Cleaners

- Clean mildew stains from grout with baking soda sprinkled on a wet toothbrush. Rinse well.
- 2. For resistant mildew, use a paste of 3 tablespoons baking soda and 1 tablespoon chlorine bleach. Wear rubber gloves and ensure adequate ventilation for this. Rinse thoroughly.

Hard Surface Cleaners

 Scrub chrome fixtures, sinks, tubs, showers, plastic laminate countertops and backsplashes, shower doors, ceramic tile, and mirrors with baking soda on a damp sponge. Rinse well and dry. Baking soda is safe and effective on fiberglass.

For tough stains on washable surfaces, cover with lemon juice and let soak for about 30 minutes before scrubbing with baking soda on a damp sponge.

Rinse well and dry.

3. For stains on old porous porcelain sinks and tubs, apply a paste of 3 tablespoons baking soda and 1 tablespoon hydrogen peroxide. Let sit a while before rinsing.

Rust Buster

Remove rust stains on tile, tub, and sink by scrubbing with baking soda sprinkled on a damp nylon scrubber. Rinse well.

Septic Tank Saver

Avoid septic system problems by flushing 1 cup baking soda down the toilet every week. Baking soda creates the optimum environment for bacterial digestion of solid waste and clarification of the liquid leaving the septic tank.

Shower Curtain Cleaners

 Scrub mildew spots from plastic shower curtains with baking soda sprinkled on a scrub brush. Rinse well and dry.

2. Clean machine washable plastic shower curtains by washing on the gentle cycle with two bath towels (for scrubbing action) and ½ cup gentle laundry detergent and ½ cup baking soda. Add 1 cup white vinegar to the rinse cycle. Do not spin dry; hang immediately to air-dry.

Soap Scum Remover

For tubs and showers with a tough soap scum film, mix ½ cup baking soda, ½ cup vinegar, and 1 cup ammonia in 1 gallon warm water and use a sponge or mop to apply. Maintain adequate ventilation. Rinse well.

Toilet Bowl Cleaners

- Clean toilet bowls routinely with ½ cup baking soda and a toilet brush.
- 2. To clean stained bowls, pour in ½ cup baking soda followed by ½ cup vinegar and scrub with a toilet brush.

Wastebasket Deodorizer

Sprinkle baking soda into the bathroom wastebasket as needed to control odors.

Water Spot Remover

Remove spots caused by hard water or soap on faucets and shower doors with baking soda sprinkled on a damp sponge. Rinse well.

LAUNDRY

Acid Stain Spotters

- Rinse acids (citrus juices, battery acid, urine, bowl cleaners) immediately from clothing with cool water and then spinkle with baking soda to neutralize any acid residue. Launder.
- 2. Pretreat dried-on acid stains with a paste of 3 tablespoons baking soda and 2 tablespoons water to neutralize the dry acid before it is reactivated in the wash water.

Bathing Suit Soak

Presoak bathing suits in a solution of 4 tablespoons baking soda in 1 quart water to remove sea salts or pool chemicals before laundering.

Bleach Extender

Instead of a full cup of bleach, use $\frac{1}{2}$ cup bleach together with $\frac{1}{2}$ cup baking soda to boost the bleaching action and freshen the wash.

Blood Stain Scrub

Scrub blood stains with a paste of 3 tablespoons baking soda and 2 tablespoons water. Pour a little hydrogen peroxide (check colorfastness first) on the area and rub lightly just before washing.

Brightner

Whiten socks and dirty clothes by using ½ cup baking soda with your regular liquid laundry detergent.

Delicates Wash

- Refresh hand washables that have a stale odor by soaking in a solution of 4 tablespoons baking soda in 1 quart water. Rinse well, squeeze, and air-dry.
- Launder dirty delicates in a solution of 2 teaspoons mild liquid hand dishwashing detergent and 4 tablespoons baking soda in ½ gallon water. Rinse and dry as usual.

Dry-Cleanables Wash

Some small "dry clean only" colorfast items can be safely cleaned in a solution of 4 tablespoons baking soda in 1 quart water. Rinse thoroughly and dry gently.

Fabric Softener

Add ½ cup baking soda to the wash load to make clothes feel soft and smell fresh.

Hamper Helper

Keep hampers odor free by sprinkling baking soda on each layer of added clothing. This will also keep the hamper itself from picking up odors.

Iron Cleaner

Remove residues from the bottom of a cooled iron by scrubbing with a paste of 3 tablespoons baking soda and 1 tablespoon water. Rinse well and dry.

Odor Beater

Presoak sweaty or smoky colorfast work clothes, gardening clothes, athletic uniforms, exercise wear, head bands, knit hats, and dance costumes for an hour or two in a solution of $\frac{1}{2}$ cup baking soda in 1 gallon water. This will work on stains too.

Prespotter

Prespot dirty cuffs, perspiration stains, and most food stains by scrubbing with a paste of 3 tablespoons baking soda and 2 tablespoons water. For worse stains, let the paste work for an hour or more before washing.

Ring-Around-the-Collar

Pretreat ring-around-the-collar by scrubbing with a paste of 3 tablespoons baking soda and 2 tablespoons water. Pour a little white vinegar on the area and rub lightly just before washing.

Washer/Dryer Cleaner

Clean scuff marks and dried-up laundry liquids from the tops of washers and dryers with baking soda sprinkled on a damp sponge. Rinse with a clean damp sponge and dry.

Washer Deodorant

Sprinkle ½ cup baking soda into the washer before going on vacation to avoid development of musty odors by your return.

Wine/Gruit Juice Stains

Scrub a fresh wine or fruit juice stain on colorfast fabric with a paste of 3 tablespoons baking soda and 1 tablespoon water. Stretch the treated area tightly over a bowl and pour boiling water over and through the stain until the baking soda is washed away.

PLAYROOM

Balloon Blower

Stretch a small balloon a few times to make it easier to inflate. In the following order, add 2 tablespoons water, 1 teaspoon baking soda, and 4 tablespoons lemon juice or vinegar to a clean empty soda bottle. Then quickly fit the balloon over the mouth of the bottle. Carbon dioxide released from the baking soda inflates the balloon.

Color Magic

Shred several leaves of red cabbage and put them in a zip-closing plastic bag. Pour hot water (not hot enough to melt the plastic) over the cabbage and zip the bag shut. Let sit until the water is cooled and blue. Pour the blue water into a clear container. Add 1 tablespoon baking soda, and the blue water turns bright green. Add 2 to 3 tablespoons white vinegar and it turns purple. The secret to this magic is hidden in the cabbage. Red cabbage contains a chemical that is sensitive to acids and alkalies. In acids like the vinegar, it is purple. In alkaline solutions, as with baking soda, it turns green.

Dancing Seeds

Pour 4 ounces water into a large glass. Add 1 teaspoon baking soda and stir until dissolved. Add 4 or 5 apple seeds. Add 4 teaspoons lemon juice or white vinegar and stir gently. The seeds will rise and fall in the water as they are carried to the surface by carbon dioxide bubbles and then dropped as the bubbles burst.

Dall Bath

 Renew old doll clothes in a soak of 2 tablespoons baking soda and 2 cups water. Rinse and air-dry.

2. Clean plastic dolls of dirt, stains, crayon, ink, and marker with a wet toothbrush and paste of 3 tablespoons baking soda and 1 tablespoon dishwashing liquid. Rinse well and dry.

Footprints

- For parties and holidays cut out "feet" stencils (the sillier the better) from cardboard. Use the stencils to sprinkle baking soda feet onto carpets or rugs. You can also do this with stencils of pumpkins, Christmas trees, Easter bunnies, or names. When the party's over, the baking soda vacuums right up.
- 2. The same stencils can be used outdoors for driveway or sidewalk art. Mix a few containers of baking soda paste by blending 1 cup baking soda and ½ cup water and then adding a few drops of a different food coloring to each. Use a sponge to stencil your creations. Let dry. They can be hosed away when through.

Glass Art

The stencils and baking soda pastes for sidewalk art (see "Footprints," above) can also be used indoors to decorate windows. Remove when through with a damp sponge (this cleans the windows at the same time). Rinse and dry.

Plastic Toy Cleaner

- Clean plastic toys with baking soda sprinkled on a damp sponge. Rinse well and dry.
- 2. Spot-clean dirt, stains, crayon, ink, and marker with a wet toothbrush and a paste of 3 tablespoons baking soda and 1 tablespoon dishwashing liquid. Rinse well and dry.

Play Clay

In a saucepan, blend 2 cups baking soda and 1 cup cornstarch. Add 1½ cups cold water, and a few drops of food coloring if desired, and cook over medium heat, stirring constantly. When the mixture is the consistency of mashed potatoes, turn out onto a plate and cover with a damp cloth. When cool enough to handle, it's ready to use. Objects made from this clay are best air-dried for 24 hours; thick pieces may take longer. The drying of thin pieces can be accelerated by 15 minutes in a preheated 350°F oven. Too-rapid drying of thin objects or oven drying of thicker objects may cause cracking. Paint dried pieces with watercolors, poster paints, or felt-tip pens, and then coat with shellac, varnish, liquid plastic, or nail polish. Unused clay can be stored in a tightly sealed plastic bag in the refrigerator, but should be warmed to room temperature before use.

Stalactites and Stalagmites

Glue 2 small glass baby food jars about 4 inches apart on a large, flat disposable plastic plate. Fill the jars with hot water. Dissolve 1 tablespoon baking soda and a few drops of yellow food coloring in one, and 1 tablespoon baking soda and a few drops of blue food coloring in the other. Put the ends of a foot-long piece of wool yarn in the solution in each jar. Let the middle hang between the jars while remaining at least ½ inch above the plate. After a few days, stalactites (growing down) will form on the yarn and stalagmites (growing up) beneath it. Baking soda solution travels up the yarn and drips onto the plate. The drops on the plate evaporate, leaving a baking soda stalagmite. Water evaporating

Baking Soda Bonanza

from the solution absorbed in the yarn leaves a baking soda stalactite.

Toy Box Cleaner

Clean and deodorize plastic and laminate toy boxes with a solution of 4 tablespoons baking soda in 1 quart water. Apply with a damp sponge, rinse, and wipe dry.

EVERY ROOM

All-Purpose Cleaner

A solution of ½ cup ammonia, 2 tablespoons baking soda, and ¼ cup white vinegar in 2 quarts water will clean and degrease virtually all colorfast washable surfaces around the house. Apply with a sponge, rinse, and dry. Use rubber gloves and good ventilation.

Ashtray Tamers

 Use a solution of 1 tablespoon baking soda in 1 cup water to thoroughly clean ashtrays.

Control smoking odors by covering the bottom of ashtrays with baking soda. This will also quickly extinguish smoldering butts.

CD and DVD Cleaner

Clean dirt and smudges from CDs and DVDs by gentle sponging with a solution of 1 tablespoon baking soda in 1

The Household Alternative

cup water. Rinse with a clean damp sponge and gently dry with a soft lint-free cloth.

Closet Deodorizers

- Place an open box of baking soda on each closet shelf to keep clothes from absorbing odors. Replace every 3 months.
- If you store clothes in garment bags, sprinkle some baking soda into the bottom of each to keep the clothes smelling fresh.

Deodorizer Spray

Make a simple spray deodorizer by filling a plant mister with a solution of 2 tablespoons baking soda in 2 cups water. Mist the air in rooms afflicted with stale food or smoke odors.

Diamond Ring Cleaner

Soak prong-set diamond rings in a solution of 1 tablespoon baking soda and 1 teaspoon ammonia in 1 cup water to soften soap, detergent, hand cream, and body oil residues for easy brushing away.

Flower Power

Instead of arranging silk flowers in an empty vase or in a Styrofoam base, fill the vase halfway with baking soda. This will anchor the flowers and absorb room odors.

Gym Aid

 Periodically deodorize gym bags by adding 1 cup baking soda, closing, shaking to distribute the baking soda well, and letting sit overnight. Shake or vacuum out the baking soda before use.

Pack a fresh box of baking soda in the gym bag for the gym locker. Open it and put it on a locker shelf

to control odors.

Leather Cleaner

Clean mildew spots on leather by rubbing with a paste of 3 tablespoons baking soda and 1 tablespoon water. Dry overnight and gently brush away. Re-polish.

Luggage Odor Beater

 Sprinkle baking soda liberally everywhere inside luggage that has acquired a musty odor in storage. Close, let sit overnight, and vacuum out.

Between trips, sprinkle baking soda inside suitcases, trunks, and travel bags to keep them odorfree. Vacuum out when ready to use.

Marble Cleaner

Cover stains on marble with lemon juice or white vinegar and then sprinkle with baking soda. Rub with a damp sponge, rinse, and dry.

Metal Cleaners

- Clean stainless steel, chrome, silver, and gold by scrubbing with baking soda on a damp sponge. Rinse well and dry.
- 2. Clean copper, bronze, and uncoated brass with a paste of 3 tablespoons baking soda and 1 tablespoon white vinegar or lemon juice. Rinse well and dry.

Musty Book Refresher

Deodorize a musty book by first ensuring that it's totally dry. Dust the pages with baking soda and shake or brush it out after several days.

Needlework Cleaner

Clean colorfast needlework pieces by soaking in a solution of 1 tablespoon baking soda and $\frac{1}{4}$ teaspoon gentle dishwashing liquid in 1 quart water. Rinse well, block, and airdry.

Radiator Cleaner

Clean grime and spatter from radiators and baseboards by scrubbing with baking soda sprinkled on a damp sponge. Rinse well and dry.

Roach Remover

Mix a container of 1 cup baking soda and 1 cup sugar. Sprinkle in infested areas as a pesticide-free roach killer.

Saltwater Aquarium Stabilizer

The alkalinity of saltwater (marine) aquariums and reef tanks can be adjusted with carefully measured additions of baking soda. The mildly alkaline pH of baking soda plus its natural buffering ability help to maintain a healthy and productive marine environment.

Sneaker Deodorant

Control the odor of all athletic footwear by sprinkling in 2 tablespoons baking soda between uses and distributing over the entire insole. Shake out into the wastebasket or toilet bowl for extra service before wearing again.

Upholstery and Carpet Cleaners

 Sprinkle carpeting with baking soda before you vacuum. Let sit for 15 minutes before removing. The carpeting will be clean and deodorized.

2. Clean spills or accidents (pet or baby) on colorfast carpets and cloth upholstery with club soda. Let dry thoroughly overnight. Then sprinkle baking soda on the affected area and let sit for 15 minutes before vacuuming it up.

3. Absorb oily and greasy stains on carpeting and cloth upholstery with a mixture of 1 tablespoon baking soda and 1 tablespoon salt. Sprinkle the powder on the stain, brush lightly, let sit a few hours, and then vacuum.

 Absorb oily and greasy stains on colorfast carpeting and cloth upholstery with a paste of 3 tablespoons

The Household Alternative

baking soda and 1 tablespoon water. Rub the paste into the stain, let dry, and vacuum.

Vinyl Upholstery Cleaner

Clean vinyl upholstery quickly and easily with baking soda sprinkled on a damp sponge. Rinse and dry.

Wax Remover

Rid washable hard surfaces of waxy marks from candles, rayon, or paraffin by scrubbing with a paste of 3 tablespoons baking soda and 1 tablespoon water on a nylon scrubber.

Window Blinds Cleaner

Clean metal and plastic window blinds by soaking them in a bathtub filled with warm water and 1 cup baking soda and then brushing away the dirt. Rinse outside with a hose and hang on the clothesline or over a railing to air-dry.

GARAGE AND DOCK

Accidents Response

Keep a box of baking soda in the car or boat in case of passenger motion sickness or pet accident. Cover the mess with baking soda to improve the sight and smell until it can be cleaned. The baking soda will make the eventual cleanup easier as well.

Auto and Boat Deodorizer

1. Neutralize lingering odors by sprinkling baking soda liberally on all dry carpeting and cloth upholstery. Leave on at least 1 hour, and then vacuum.

2. Wash plastic, vinyl, metal, and glass surfaces with a solution of 4 tablespoons baking soda in 1 quart

water. Rinse well and dry.

3. To control smoking odors, cover the bottom of ashtrays with baking soda. This will also quickly extin-

guish smoldering butts.

4. For musty or mildewed carpeting, make sure it is completely dry and then sprinkle baking soda liberally beneath (if it can be lifted) and on top. Let sit overnight before vacuuming. Repeat if necessary.

Battery Acid Neutralizer

If battery acid is splashed or spilled on the car finish, your clothing, or your skin, cover the acid immediately with baking soda and flush with plenty of water as quickly as possible.

Battery Terminal Cleaner

Clean corroded battery posts and cable connectors with a paste of 3 tablespoons baking soda and 1 tablespoon water on an old toothbrush. Rinse, dry, and coat with a small amount of petroleum jelly.

Carpet and Upholstery Cleaners

- Sprinkle on some baking soda before you vacuum auto or boat carpeting. Let sit for 15 minutes before removing. The carpeting will be clean and deodorized.
- Clean spills or pet accidents on carpets and colorfast cloth upholstery with club soda. Let dry thoroughly overnight. Then sprinkle baking soda on the affected area and let sit for 15 minutes before vacuuming it up.
- 3. Absorb oily and greasy stains on carpeting and cloth upholstery with a mixture of 1 tablespoon baking soda and 1 tablespoon salt. Sprinkle the powder on the stain, brush lightly, let sit a few hours, and then vacuum.
- 4. Absorb oily and greasy stains on carpeting and cloth upholstery with a paste of 3 tablespoons baking soda and 1 tablespoon water. Rub the paste into the stain, let dry, and vacuum.

Car-Wash Booster

Add $\frac{1}{2}$ cup baking soda to your pail of suds for easier cleaning.

Chrome and Glass Cleaner

Remove soot, sap, bird droppings, bugs, tar, and grease from windshields, headlights, rocker panels, bumpers, and chrome trim by scrubbing with baking soda on a damp sponge. Rinse and dry or let dry and wipe off the residue.

Aiberglass Cleaners

 Safely clean stains on fiberglass car and boat bodies with baking soda on a wet sponge. Rinse, dry, and re-polish.

For tough stains, scrub with a paste of 3 tablespoons baking soda and 1 tablespoon water. Let the paste

dry and then wipe the powder away.

Fire Extinguisher

You should keep a properly rated fire extinguisher in the car, boat, and garage to extinguish small oil, gas, and engine fires. Have a large box of baking soda available too. If you have to use the baking soda, broadcast it from a safe distance at the base of the flames. If the fire is too intense to be quickly extinguished, call the fire department immediately.

Garage Floor Cleaners

1. Absorb spilled oil and grease from the garage floor by covering with baking soda.

Clean oil-stained garage floors by wetting the area and scouring with baking soda and a scrub brush.

Hand Cleaners

 Wash greasy hands with soap and a liberal sprinkle of baking soda.

Wash gasoline and paint thinner odor from hands with soap and a liberal sprinkle of baking soda.

Motorcycle Maintenance

Clean glass, chrome, fiberglass, and painted metal motorcycle parts with baking soda on a damp sponge. Wet the surface first; rinse well and dry after cleaning.

Sailor's Scrub

Clean filmy or spotted chrome, glass, and brass on boats with baking soda on a damp sponge. Rinse well and buff dry.

Vinyl and Drop-Top Cleaners

Clean stained vinyl tops and canvas convertible car and boat tops by wetting, sprinkling with baking soda, and scrubbing with a soft bristle brush. Then wash, rinse, and dry.

Vinyl Upholstery Cleaner

Safely clean vinyl auto and boat upholstery by sponging with a solution of 1 tablespoon baking soda in 1 cup water. Rinse well and dry.

OUTDOORS

Air Mattress Cleaner

Clean spills, stains, and oils from inflatable mattresses and pool floats with baking soda sprinkled on a damp sponge. Rinse well.

Aluminum Cleaner

Clean aluminum screens, doors, and furniture with a solution of $\frac{1}{2}$ cup baking soda in 1 gallon warm water. Rinse well. Protect clean painted aluminum with auto wax.

Ball Cleaner

Use baking soda on a damp sponge to clean balls of the base, basket, billiard, bocci, bowling, foot, golf, soccer, and volley varieties. Rinse and dry.

Birdbath Cleaner

Safely scour birdbaths with baking soda and a wet scrub brush. Rinse well and refill.

Camper's Comrade

 If your sleeping bag smells musty or of perspiration, sprinkle with baking soda inside and out. Leave the baking soda for a few hours before brushing, shaking, or vacuuming off.

Prevent musty sleeping bags and tents next season by making sure they are totally dry and then sprinkling them liberally with baking soda before packing them away.

3. If you can't do the camp laundry as soon as you'd like, rinse washables in a solution of ¼ cup baking soda in 1 gallon water. Wring out and air-dry.

Campfire Controller

Bring a spray bottle with a solution of 1 tablespoon baking soda in 2 cups water on your next camping trip. When it's time to head home, use this spray to ensure that the campfire is completely extinguished.

Fisher's Friend

- 1. Clean and deodorize fishing poles, tackle boxes, creels, bait boxes, waders, and gutting/scaling utensils with a solution of ¼ cup baking soda in 1 quart water. Rinse well.
- 2. Deodorize fishy hands by wetting and scrubbing with baking soda.
- 3. Deodorize fishy clothes by soaking in a solution of $\frac{1}{2}$ cup baking soda in $\frac{1}{2}$ gallon water before laundering.

Garden Glove Cleaner

Clean soiled cloth garden gloves by soaking in a solution of ¹/₄ cup baking soda in 1 quart water before washing.

Garden Mildeweide

Fill a spay bottle with a solution of 1 teaspoon baking soda in 1 pint water. Spray as needed to combat powdery mildew on cucumbers, zucchini, melons, roses, lilacs, and other afflicted shrubs.

Grass Catcher Care

After the final mowing of the season, sprinkle the inside of lawnmower grass catchers liberally with baking soda to control mold growth and mustiness in storage.

Grill Cleaners

- Clean and degrease barbecue grills with a paste of ½ cup baking soda and ¼ cup warm water and a wire brush.
- Put grills with tough burned-on food in a large dishpan or stoppered sink, cover with baking soda, and add hot water until just submerged. Let soak overnight. Then clean with a wire brush and baking soda paste.

Lawn and Deck Furniture Cleaner

Clean glass-top and plastic patio furniture and the webbing of lawn furniture with a solution of ½ cup baking soda in 1 quart water. Rinse well and let air-dry.

Patio Umbrella Cleaner

Clean colorfast mesh patio umbrellas by sponging with a solution of ¼ cup baking soda and 1 teaspoon dishwashing liquid in 2 quarts water. Rinse well and let air-dry.

Planter Cleaner

Use baking soda sprinkled on a damp sponge to clean emptied planter boxes and pots before off-season storage and especially if the discarded soil had been infested with insects or molds.

Pool Cleaner

Clean pool liners with baking soda on a damp sponge.

Pool Saver

Before packing away the children's vinyl swimming pool, make sure it is totally dry and sprinkle it with baking soda before rolling up for storage.

Pool Water Stabilizer

Use baking soda to adjust swimming pool water alkalinity and pH to keep the water clear, the chlorine at optimal disinfection, and eye sting to a minimum. At the beginning of the season add 3 to 4 pounds of baking soda for every 10,000 gallons of water if the pool water is below the minimum acceptable pH of 7.2. Check the pH every week. If the pH is between 7.2 and 7.5, add 2 pounds of baking soda for each 10,000 gallons of water to raise the pH and prevent eye irritation and burning. Keep the pH below 7.8 to prevent clouding, especially in hard water areas or when using a calcium chlorinating agent. Control pH without fluctuation by maintaining alkalinity in the 110 to 150 ppm range when using stabilized chlorinated isocyanurates, and in the 60 to

Baking Soda Bonanza

110 ppm range for other chlorinating agents. Each $1\frac{1}{2}$ pounds of baking soda adds 10 ppm alkalinity for every 10,000 gallons of water.

RV Toilet Tamer

Control odors in your recreational vehicle bathroom with an open box of baking soda. Be sure to replace it every 3 months.

Spa Cleaner

Clean hard water deposits and body oils from acrylic and fiberglass spas with baking soda sprinkled on a damp sponge.

Sports Cleaner

Clean graphite, plastic, fiberglass, and aluminum sporting equipment plus their protective bags and covers with a solution of 4 tablespoons baking soda in 1 quart water, or, for tougher jobs, baking soda on a damp sponge. Rinse and dry.

Sports Drink

Make your own electrolyte replacement sports drink by mixing ½ gallon bottled water, 1 level tablespoon baking soda, 2 teaspoons salt, 3 tablespoons sugar, and powdered iced tea or fruit-flavored drink mix. This is not recommended for people on a salt-restricted diet.

Swing Seat Cleaner

Clean tree sap, grime, and bird droppings from plastic and metal swing sets with baking soda sprinkled on a damp sponge.

Tent Cleaner

Clean mildew spots from colorfast tents by scrubbing with a paste of 3 tablespoons baking soda and 1 tablespoon water and a soft bristle scrub brush. Rinse well. For tougher infestations, let the paste dry first before brushing or rinsing away.

Traction Action

In the winter, sprinkle baking soda on icy steps and porch as a traction aid. It won't harm outside brick, wood, or concrete surfaces, it's safe on your shoes, and it won't damage the floor if it's tracked inside.

The Environmental Alternative

The unique versatility of baking soda has been applied to no less an undertaking than the cleaning, deodorizing, and deacidifying of the environment. Baking soda combats acid rain as effectively as it curbs acid stomach. It is as safe in removing paint from an airliner as it is in polishing stains from your teeth. It is as effective in reducing lead in drinking water as it is in cleaning corrosion from a car battery. At a time when high-tech environmental solutions can be as dangerous as they are beneficial, baking soda is safe, effective, and economical.

MUNICIPAL WATER TREATMENT

Drinking water has become a significant source of lead, with millions of Americans exposed to lead-contaminated water every day. Detecting contamination is complicated by the fact that lead levels in drinking water can vary markedly between distribution systems in the same area, between houses supplied by the same system, between different types of taps, and at different times of day at a single tap.

Lead and other toxic metals enter drinking water that is

corrosive to piping in the distribution system and the home. Corrosion occurs when the water is acidic or contains an oxidizing agent, such as chlorinating compounds or even just dissolved oxygen. Under these conditions, metallic lead from lead pipes or solder can be leached into the water. In some parts of the country, acid rain and acid clay soils produce potable water supplies that are "soft," with the low dissolved mineral content and acidity that promote lead leaching. Fortunately, lead can be controlled with sodium bicarbonate. Dissolved lead and bicarbonate react to form a durable, impermeable coating inside pipes that protects against further leaching of lead and other metals. With constant concern over the problem of lead poisoning in children, sodium bicarbonate is becoming a powerful weapon in the fight to keep the nation's water safe and potable.

Acid Lake Recovery

Another side effect of acid rain, and perhaps one more widely known, is the formation of acid lakes. Most fish, and the aquatic organisms that feed them, thrive only in neutral water. Too much acidity or too much alkalinity is fatal. Baking soda, the age-old treatment for relieving stomach acid, is an effective treatment for acid lakes as well.

James Bisogni, Jr., a professor at Cornell University, was the first to recognize and demonstrate the obvious advantages of sodium bicarbonate. In 1985 he adopted Wolf Pond, a fifty-acre acid lake in the Adirondacks, as his laboratory. At the time, this lake could no longer support game fish. Only a small number of trash fish survived. The simple addition of approximately twenty tons of baking soda succeeded in neutralizing the acid and restoring the health of the lake.

Acid Rain Relief

Both coal and oil burning power plants produce acid gas emissions when the sulfur contained in the fuel is released up the flue stack in the form of sulfur dioxide. This acid gas is ultimately returned to earth as acid rain. When finely ground sodium bicarbonate is injected into the acidic flue gases of power plant boilers, it can remove more than 90 percent of the sulfur dioxide. The sodium bicarbonate reacts with this gas to form solid salt cake (sodium sulfate) plus steam and carbon dioxide.

Waste Treatment

Sodium bicarbonate is used in municipal and industrial wastewater and sewage treatment plants to ensure proper biological control in waste digesters. This process uses bacteria to reduce organic sludge and transform it into stable and compact solid residues. The drier and more compact these residues can be made, the less solid waste there is for disposal. Waste-digesting bacteria need a slightly alkaline environment to work efficiently, but their decomposition of certain wastes creates acids. If too much acid builds up, conversion of waste to solid residue slows down, producing a wet and bulky sludge for disposal. Sodium bicarbonate keeps digesters running efficiently, aids in toxic metals removal, and provides the odor control important to treatment plant neighbors.

Paint Stripping

Sodium bicarbonate's utility in keeping air and water clean has been further extended to a clever alternative to industrial-scale paint stripping. This eliminates the need for hazardous chemical or mineral processes while minimizing the creation, and disposal costs, of hazardous coating wastes.

Traditionally there have been two basic alternatives for stripping paint from large surfaces such as industrial equipment, metal superstructures, and aircraft. Chemical strippers dissolve paint that contains toxic metals to form a chemical sludge that requires costly disposal as hazardous waste. Chemical strippers also pose a contact and inhalation danger to workers. The alternative to chemical strippers has been sandblasting. This technique is fast, effective, and economical, but can generate hazardous silica dust. Blasting with minute plastic beads instead of sand removes the threat of silicosis, but retains dust inhalation problems.

During the restoration of the Statue of Liberty, a compressor was used to direct a stream of dry bicarb to clean the tar coating from the inside of her delicate copper skin. Blasting with baking soda cleaned the copper without abrasion, and without exposing workers in the statue to hazardous blasting media or chemicals. This led to the development of a new paint-stripping technique that takes full advantage of sodium bicarbonate's effective and safe cleaning properties. Blasting with a pressurized slurry of baking soda in water is the safest and most effective alternative to workers and environment to the traditional paint-stripping techniques. The slurry form minimizes dust generation and can be used on virtually all hard surfaces, including plastic composites. Because the bicarbonate is water soluble, it is easily

washed from the coating waste, which can then be concentrated for disposal. The separated bicarbonate solution can be sewered, if local regulations allow, or recovered for additional use as an acid neutralizer in treating electroplating wastes or supplying alkalinity to sewage treatment plants.

On industrial plant sites, bicarb blasting is preferred because it can be used to remove rust, corrosion, and grease, in addition to coatings, and can be used safely on sensitive rotating and hard-to-reach equipment parts. This method of paint removal has also found growing acceptance in the aviation industry, where stripping paint from aircraft is vitally important to detect metal fatigue, cracks, corrosion, and other structural problems. As an alternative to the normal methylene chloride—based strippers, bicarbonate blasting has so far successfully addressed all safety, efficacy, environmental, and worker hygiene concerns while minimizing waste disposal problems.

Soil Saver

Baking soda's safety, efficacy, and economy are not restricted to improving our air and water. They can be applied to the ground beneath us with equal benefit. Among the newest technologies to apply baking soda to an environmental problem is the treatment of contaminated soils. There are numerous sites in the United States, and abroad where the ground itself bears detectable levels of hazardous chemicals. Of great concern are the various halogenated (i.e., containing chlorine or bromine) organic chemicals that have seeped into the ground at manufacturing sites and landfills, as well as pesticides that have accumulated after application or that have been inadvertently liberated during manufacture or disposal.

The standard treatment for contaminated ground is either removal to a special hazardous waste landfill, or incineration. Transport to a designated landfill is not favored currently because it simply moves the hazard rather than eliminating it. Incineration is preferred since the chemical contaminants are effectively destroyed. While this would appear to be a straightforward approach, it is a logistical challenge and can be an economic nightmare. Once the extent of contamination has been determined, this entire volume of soil must be excavated and fed to the incinerator. Depending upon the amount and accessibility of the soil to be treated, incineration may be done on site. Otherwise, it must be shipped by secure transport to an appropriate facility. Incineration costs can be as much as \$2,000 per ton on site and up to 50 percent greater off site.

The U.S. Environmental Protection Agency, in conjunction with the Navy's Civil Engineering Lab, has developed a baking soda solution to this environmental problem. In 1990, they invented an efficient, relatively inexpensive method for decomposing PCBs (polychlorinated biphenyls) and other halogenated contaminants. This process known as base-catalyzed decomposition (BCD) involves crushing and screening the contaminated soil, and then blending in sodium bicarbonate at 10 percent of its weight. This blend is then heated for about one hour at 630°F. The resulting soil is nonhazardous and can be returned to the site of its excavation. Cleanup is done on site, eliminating transportation costs and minimizing air emissions and toxic residual wastes. It is the safest and most effective chemical method available, and can be implemented for only about 10 percent of the cost of incineration. Since its development, the BCD process has been used extensively in U.S. Superfund sites.

Baking and Baking Soda

wheat kernels are passed between two grooved rollers turning at different speeds. This shearing action separates the endosperm (starch and protein) from the bran and germ, which go on to separate grinding and sieving. The endosperm is crushed and ground to a mixture of coarse and fine flours. The fine flour is sieved off and the rest is further ground. This combination of grinding and sieving is repeated several times to collect all the fine flour possible. Semolina is made by collecting some of the coarse flour after the first milling. This semolina is a high protein flour for making dried pastas, but it has a weaker gluten than durum semolina.

Most baking flours are treated with a bleaching and aging agent. Bleaching ensures a uniform whiteness, but also destroys the small amount of vitamin E in the flour. The bleaching agent also ages the flour by modifying its proteins to improve gluten formation. Some flours are not bleached but are still aged, with potassium bromate or potassium iodate, to improve their gluten. The last step before the final packaging of most white flour is addition of vitamin and mineral enrichment with niacin, thiamin, riboflavin, iron, and in some cases calcium.

Common Wheat Flours

ALL-PURPOSE FLOUR A bleached, enriched blend of hard and soft wheat flours intended for use in a wide range of foods.

UNBLEACHED FLOUR Unbleached (but aged) all-purpose flour.

BREAD FLOUR Hard wheat flour; some flours sold as bread flour have added barley malt flour (food for the yeast) and potassium bromate (for gluten development).

Baking Soda Bonanza

BROMATED FLOUR Hard wheat flour to which up to fifty parts per million of potassium bromate has been added as a gluten developer. Bromated flours were developed primarily for biscuits but are also used for bread. They promote a faster rising and an airier loaf.

HARD WHEAT FLOUR This is simply what its name indicates, and is produced in both white and whole wheat. It is more likely found in a specialty food store than in a supermarket, and is used primarily for bread baking.

WHOLE WHEAT FLOUR A medium-fine hard wheat flour with the germ retained but the bran either partially or totally removed; used mostly for bread, but can be mixed with white flour for nearly all non-pastry baking.

GRAHAM FLOUR This is supposed to be the entire coarsely ground wheat kernel (endosperm, germ, and bran). This name, however, is used loosely to include coarse whole wheat flours. It is used the same way as whole wheat flour.

SELF-RISING FLOUR Soft wheat flour blended with sodium bicarbonate, monocalcium phosphate, and salt. It is popular for making biscuits, muffins, and quick breads. Self-rising flour is sometimes sold as phosphated flour.

CAKE FLOUR Especially fine soft wheat flour that has been treated to weaken its gluten. This treatment allows incorporation of large amounts of shortening into mixtures and the development of good crumb in cakes and flakiness in pastries. Soft wheat flours are also used commercially for making doughnuts, cookies, crackers, and pretzels.

GLUTEN FLOUR White flour from which nearly all the starch has been removed. It is expensive and intended for dietetic

Baking and Baking Soda

purposes, but can be used in small amounts in breads made from grains like rye and barley that have little or no gluten.

Other Flours

While much less commonly available than wheat flours, meals and flours from other nutritional sources are becoming increasingly popular.

AMARANTH FLOUR Amaranth is an ancient South American low gluten grain that has been rediscovered by American consumers. It is higher in protein than corn or beans, higher in fiber than wheat, rice, soybeans, or corn, the highest in iron of the cereal grains, and rich in vitamins. It also contains the essential amino acid lysine, which is absent in most other cereal grains. The flour is milled from the whole grain. A blend of amaranth and whole wheat is reported to rival meat or eggs as a complete protein source.

BARLEY FLOUR A light, high protein, very low gluten flour milled from whole hulled barley.

BUCKWHEAT FLOUR Buckwheat is a cereal grass, not a grain, and resembles wheat in name only. It contains twice the B vitamins of wheat and is best known for its use in pancakes. The dark flour is milled from the unhulled groat, while the light flour is milled from the hulled groat and has a more delicate flavor.

CORN FLOUR The finest flour from the milling of corn endosperm. In descending order of size, the other flours are segregated for cornflakes, grits, coarse corn meal and fine corn meal.

Baking Soda Bonanza

MILLET FLOUR Ground from the whole hulled grain, it contains no gluten. Millet is considered one of the most nutritious grains, and owing to its alkaline nature is sometimes recommended in diets for people with ulcers or colitis.

OAT FLOUR The fine flour resulting from the dehulling of the oat grain prior to the rolling of the oat groats. This flour contains no gluten, and is used in place of rolled oats in baked goods. The addition of oat flour to home-baked products is used to maintain freshness, since oats contain a strong natural antioxidant.

QUINOA FLOUR Quinoa (KEEN-wah) is another recent rediscovery of ancient South American origin. Like amaranth, it contains the essential amino acid lysine, and is high in protein and iron. Unlike amaranth, it is not a grain but the fruit of an herb. Quinoa flour is milled from the whole "grain" and is very low in gluten.

RICE FLOUR Milled from broken kernels of white or brown rice; it contains no gluten. Rice flour imparts a slightly grainy texture to baked goods. Since it is essentially tasteless, it can be used in many types of baked goods, especially those with strongly flavored flours, like soy or rye.

RYE FLOUR This can vary from a light flour, milled from endosperm, to a very dark flour, milled from the whole grain and suitable for pumpernickel. Rye flour sold for bread baking may contain some hard wheat flour.

SOY FLOUR In the strictest sense, this is flour milled from raw soybeans, while soya flour is milled from toasted soybeans. Soy flour is generally milled from whole soybeans into one of three types of flour: full-fat, low-fat, or defatted.

Baking and Baking Soda

Full-fat flour is the most widely available for use in home baking. Because of its strong nutty flavor, it is often used with other flours or in recipes with spices, nuts, or chocolate to mask its taste. Soy flour is used in baked goods for its high protein content and ability to retard staling.

TEFF FLOUR A relative newcomer to the United States via its ancient roots in Africa, teff boasts higher iron content than wheat, rice, millet, or oats. The flour is milled from the whole grain, which can be white, red, or brown. The white variety imparts the mildest flavor.

TRITICALE FLOUR A low gluten wheat-rye crossbreed produced for developing countries because of its high protein content. Although perishable and not widely available in this country, it is a good pastry flour and useful for high protein bread. Gentler kneading is required.

Because nonwheat flours contain little or no gluten, they are most successfully used in baking soda—leavened rather than yeast-leavened recipes. For those interested in exploring the nutritional or culinary possibilities of substituting the more common nonwheat flours in whole or part for wheat flour in recipes, the following table can be used as a guide.

Substitutes for 1 Cup of Wheat Flour in Baked Products

Rye Flour 1½ cups
Oat Flour 1½ cups
Corn Flour 1 cup
Soy Flour 1½ cups

Barley Flour 11/3 cups

Rice Flour 1 cup minus 2 tablespoons

Baking Soda Bonanza

Combinations of flours tend to produce better results. For example, a mixture of 1 cup minus 2 tablespoons of rice flour and 1¼ cups of rye flour will substitute for 2 cups of wheat flour. The bland flavor of the rice flour minimizes the strong rye taste, while the rye flour minimizes the grainy texture produced by the rice flour.

LEAVENING AGENTS

Leavening is simply the act of introducing gas bubbles into a dough or batter so that it expands. The three basic approaches to leavening are generation of carbon dioxide by the reaction of baking soda with an acid, generation of carbon dioxide by fermentation of yeast, and mechanical incorporation of air by whipping or beating. A general rule of thumb is that soda leavens batters while yeast leavens dough. There are, of course, exceptions. Yeast produces carbon dioxide slowly, so it requires a strong and elastic matrix to contain the generated gas. A relatively stiff, glutencontaining dough is needed. Batters and weak doughs are not suited to yeast leavening because they can't trap the slowly released carbon dioxide. Most of the gas would exit the mixture as it was produced. This type of mixture needs a fast-acting gas source, one that will aerate the batter or dough quickly, but not so quickly that it will collapse during baking once the leavening period is over. In the past century and a half, no more suitable product than baking soda has been found. Baking soda can liberate carbon dioxide at a controlled rate; it is inexpensive, highly purified, and nontoxic.

Baking Soda

The combination of baking soda with an acid liberates carbon dioxide, which causes the batter or dough to expand. Baking soda is often used in recipes with naturally acidic ingredients like sour milk, buttermilk, yogurt, molasses, chocolate, and fruit preserves. The following combinations can serve as a guide to the use of baking soda with some common naturally acidic ingredients; each can be used in place of two teaspoons of commercial baking powder.

- * ½ teaspoon baking soda per cup of buttermilk
- * ½ teaspoon baking soda per cup of milk that has been soured with 1 tablespoon white vinegar or lemon juice
- * ½ teaspoon baking soda per cup of milk that has been soured with 1¾ teaspoons cream of tartar
- * ½ teaspoon baking soda per cup of molasses
- * ½ teaspoon baking soda per ½ teaspoons cream of tartar

A host of baking acids are used with baking soda in household baking powders and in the food industry. The first commercial baking powders were blends of baking soda with cream of tartar. This combination reacts very quickly so that a batter had to be mixed and put into the oven before the gas evolution was spent. This was succeeded by today's "double acting" baking powder using monocal-cium phosphate instead of cream of tartar. The phosphate reacts more slowly with baking soda so that about two-

thirds of the carbon dioxide is liberated during mixing of the batter, and the rest only in the heat of the oven. Another of the baking powders sold today for home use contains both monocalcium phosphate and sodium aluminum sulfate. This powder releases about one-third of its carbon dioxide during mixing and two-thirds during baking.

Many home bakers prefer using baking soda with cream of tartar or one of the acidic foods instead of using a commercial baking powder. Some use baking soda together with baking powder in certain recipes. This might seem redundant, but the added baking soda provides quicker and greater leavening action than occurs with the baking powder alone. The extra baking soda also improves surface browning and flavor development since the distinctive flavors of many baked goods are formed in the outer surfaces and diffuse inward on cooling.

Producers of commercial baked goods and baking mixes have a wide choice among the baking acids. The particular combinations with baking soda are chosen based on considerable research into their effects on the finished product. The soda and acid combination does not only produce carbon dioxide. It determines the final texture of the food and indirectly affects the flavor, moisture, and general palatability. For example, sodium aluminum phosphate is used as the acid in consumer cake mixes because it has a great tolerance to variations in mixing time, amount of liquid, and oven temperature. This makes for a decent cake, no matter how inexperienced the baker. Refrigerated tubed biscuit, muffin, and roll doughs require the slow, controlled leavening obtained with the use of sodium acid pyrophosphate as the baking acid. Otherwise, they would pop their tubes. Glucono delta-lactone is used as the acid in some

Baking and Baking Soda

tubed pizza and bread doughs because its reaction with baking soda provides results more closely resembling yeast leavening.

Yeast

Yeast for baking is available in two forms: yeast cake and active dry yeast. Yeast cake, or compressed yeast, is approximately 70 percent water versus the less than 10 percent water in active dry yeast. Yeast cake is the more perishable of the two, but slightly more active in doughs. The principle source of yeast for baking is the brewing industry, although the brewer's yeast sold in grocery and health food stores is not active and provides nutritional rather than leavening benefits.

Yeast feeds on sugars and produces carbon dioxide and alcohol, among other by-products that together give the distinctively characteristic flavor of a yeast-leavened product. Adding limited amounts of sugar to a dough will increase yeast activity. Too much sugar dehydrates the yeast cells and reduces their activity. This is why sweet breads usually require extra yeast and why cookie and cake batters are generally inappropriate for yeast. Excess salt has the same inhibiting effect as excess sugar.

Yeast fermentation produces small amounts of acids, so that as much as ¼ teaspoon of baking soda per cup of flour can be added to accelerate the rising of yeast-leavened breads. This can be tricky since enough fermentation must occur to neutralize all the baking soda. An alternative approach is to grow active dry yeast in acidic fruit juice overnight. This can then be used in a dough or batter with the baking soda. Thin batters can be baked immediately. Thick

Baking Soda Bonanza

batters or doughs can be left to rise in a warm spot for up to a half hour before baking.

Sourdoughs are a product of fermentation by natural yeasts and lactobacillus bacteria from the air. These bacteria produce the acids that account for sourdough's distinctive taste. The airborne yeast works much better in this acidic dough than does commercial yeast. The strains of yeast and bacteria native to different parts of the United States make the taste of sourdough breads unique in different regions. San Francisco sourdough is irreproducible elsewhere because its bacteria is unique to the Bay Area. Likewise, a sourdough starter transplanted from San Francisco will eventually be changed by the bacteria native to its new home.

Air

Prior to soda leavening, thin batters, as for pancakes and waffles, and raised cakes were aerated mechanically. In its simplest form this involved tediously whipping air into the batter and then cooking before all the air could escape. Beaten eggs, and especially well-beaten egg whites, can retain a fair amount of air bubbles, and were often used. Adding creamed butter and sugar, whipped to a light texture, was also a common way to incorporate air into a cake batter.

Mechanical leavening is still used in preparing batters today, but as a complement to soda leavening. Vegetable shortenings have replaced butter in many cases because they can incorporate more air and form smaller air pockets. Electric mixers have replaced hand beating and whipping to produce the smallest and most uniformly distributed air

Baking and Baking Soda

pockets. The carbon dioxide liberated from the baking soda reaction then expands the air pockets and completes the leavening.

OTHER INGREDIENTS

While flour and leavening form the foundation, the amount of water and a limited number of other ingredients determines the particular character of most baked goods, differentiating the breads from the biscuits, the rolls from the cakes, the crumbs from the flakes.

Shortening

The word "shortening" was coined in the early nineteenth century for oils or fats added to baked goods. These were supposed to "shorten" or break up the gluten to give the product a more tender crumb. The behavior of fats and oils in baking is actually more complicated, depending on the particular type and the amount used.

The liquid shortenings used today are vegetable oils—corn, safflower, sunflower, olive, and canola. Oils are used in small amounts to add moistness and tenderness to cakes, waffles, pancakes, breads, and in general any batter product that cooks to a crumb texture. The most widely used solid shortenings are based on hydrogenated vegetable oils. The hydrogenation process raises the melting point of the oil to above room temperature and produces the optimal fat crystal size to readily incorporate large amounts of air on subsequent whipping. Commercial solid shortenings, like Crisco, are hydrogenated vegetable oil that already has been whipped to

Baking Soda Bonanza

incorporate very fine air bubbles. The alternative to this type of shortening is hand-creamed butter or margarine.

Pastry calls for solid shortening so that alternate layers of dough and fat will produce the desired flakiness. Use of chilled utensils and surfaces is usually recommended for preparation of pastry doughs to avoid melting of the shortening and losing flakiness. Solid shortenings are used in cakes not to promote flakiness, but to provide a more moist and tender crumb. This can be achieved with oil alone, but the solid shortening provides leavening as well from the fine air bubbles it brings to the batter.

Shortening is also used in some bread doughs, but for a function contrary to its name. Small amounts of oil or fat do add to moistness and tenderness, as in cakes, but they also promote greater loaf volume. One theory is that this is due to a lubricating effect whereby the shortening actually allows for added lengthening of the gluten, making it more extensible and resulting in a bigger loaf.

Eggs

Eggs are used in batters mainly for their protein and fat contributions. On heating, egg protein coagulates into films or filaments that help retain the leavening gases and form an open cell or crumb structure. The egg fats serve as shortening. Beaten egg whites will hold large amounts of air and are often used with creamed butter or margarine or commercial shortening to leaven cakes.

Baking and Baking Soda

Milk

Milk provides water and, like eggs, protein and fat that contribute to crumb structure and tenderness. Milk also accelerates surface browning. Milk must be scalded and cooled prior to use in yeast-leavened products to alter milk serum proteins that would otherwise interact with flour proteins and produce a slack and sticky dough.

Sugar

Sugar (and its functional, nutritional, and caloric equivalents, honey, molasses, corn syrup, brown sugar, and malt syrup) is used principally as a sweetener in batters and doughs, and a promoter of surface browning. In moderate amounts, sugar is a nutrient for yeast, while at high levels it inhibits fermentation. Sugar is also hygroscopic (attracts water) and retards gluten development by competing with the flour for available water. That is why yeast-raised sweet doughs take longer to develop, while after baking they give moist and tender products that stay fresh longer. The sugar holds on to water and retards staling.

Salt

Salt is used in batters and doughs principally for taste. In bread doughs, excess salt slows yeast activity and makes the gluten less elastic. Compact, dense loaves result. At normal use levels, salt keeps the protein-digesting enzymes in the flour from destroying the gluten.

THE BAKING PROCESS

For leavened products like breads, biscuits, quick breads, rolls, muffins, pancakes, scones, and waffles, the baking process balances the growth of entrapped gas bubbles with the change in gluten structure from stretched to set.

In yeast-leavened doughs, most of the structure is established during raising. In the oven, the dough goes through a rapid additional expansion (oven spring) because of the growth of gas bubbles from a combination of steam, increased yeast activity, and the natural expansion of gases at high temperatures. The heat, however, soon kills the yeast and stops fermentation. The flour's starch gels in the hot dough and sets the gluten structure. This process proceeds from the outside of the loaf inward so that loaf size is established early in baking. Once the crumb at the center of the loaf is set, further baking lowers the moisture content of the bread and browns the crust.

In soda-leavened batters, the leavening gas (carbon dioxide) is generated much too quickly for the gluten to develop and contain it. These batters must be mixed just before baking. In the hot oven, it becomes a contest between the gas bubbles trying to escape and the batter trying to form a crumb structure to hold them in. Since there is no gluten to set this structure, it is formed by the combination of proteins from all sources, usually the flours, eggs, and milk. Thin batters, as for pancakes, need high heat and short cooking times to trap the leavening gases and produce a light, airy texture. Thicker batters, as for quick breads and muffins, will hold the leavening gases longer, so they can be baked at lower temperatures for longer times. This lets the middle bake thoroughly without burning the outside.

For most baked goods, staling is not the simple loss of moisture that it appears to be. During baking, water is released from the flour proteins and absorbed by its starch, which forms a gel. This is what happens when you use flour to thicken a sauce. Below the gelatinization temperature of the starch (about 140°F), the sauce is thin. At this temperature, the sauce suddenly thickens as the starch absorbs water and forms a gel. A bread, cake, or cookie fresh from the oven is soft because its starch is still gelled. On cooling, most of the starch loses some water and hardens again. Most of this water is lost through the crust as steam. This is why freshly baked bread should not cool in its pan. The trapped steam will make the crust soggy.

A small amount of starch stays gelled even after cooling and only slowly releases water to the crust. The crust absorbs this water in its dried-out starch and protein. This turns bread crust from dry and crisp to tough and leathery; a cookie or cracker turns from crisp to soft. Left uncovered, the baked good will eventually lose all of its moisture and become permanently stale. Well-wrapped goods will also stale, but they can be temporarily re-"freshed" because they still have enough trapped moisture. Wrapping tightly and reheating lets the starch absorb this moisture and gel again. This works well for breads, reviving a fresh texture, at least while it is still warm.

It is a peculiarity of the starch in flour that when its hot gel cools to room temperature and then to freezing, its water-holding capacity is at a minimum just before the freezing point. That is why, contrary to intuition, fresh bread will actually stale more quickly when stored wrapped in the refrigerator than when kept well wrapped at room temperature. This is also why it is best to freeze homemade baked

Baking Soda Bonanza

goods that will not be served within a few days. Commercially baked goods and homebaked goods from prepared mixes stay fresh longer whether refrigerated or not because most contain emulsifiers to control the movement and loss of moisture over time.

The following section combines the above ingredients, plus some delicious additions, to provide a sampling of recipes demonstrating the use of baking soda to full advantage. Most of these recipes use all-purpose flour, but you are encouraged to experiment with flour blends to develop your own unique variations. As you bake and sample each creation, you can reflect on the physical and chemical processes that conspired to such pleasing ends, or, better yet, just enjoy.

In the following recipes I generally call for cultured buttermilk powder (we use SACO) instead of fresh buttermilk, but not just for convenience. You can vary the intensity of buttermilk flavor or adjust to changes in the amount of baking soda used by adding more or less buttermilk powder, without changing the amount of liquid. Where margarine is called for, I have used vegetable oil or corn oil stick margarine. Butter is an acceptable substitute. Tub margarines and

"light" margarines will not work as well because they con-

tain less oil and more water.

QUICK BREADS AND MUFFINS

Date-Nut Bread

Serves 10 to 12

2½ cups all-purpose flour
½ cup brown sugar
1½ teaspoons baking soda
1 teaspoon salt
1 cup chopped dates
¾ cup chopped walnuts
2 large eggs, beaten
¾ cup milk
5 tablespoons white vinegar
¼ cup solid vegetable shortening, melted

- **1.** Preheat the oven to 350°F. Grease a $9 \times 5 \times 2^{1}/2$ -inch loaf pan.
- 2. In a large bowl, combine the flour, brown sugar, baking soda, and salt. Stir in the dates and walnuts. In a separate bowl, whisk together the eggs, milk, vinegar, and shortening. Add the liquid mixture to the dry ingredients and stir until just smooth. Pour the batter into the prepared pan and bake for about 60 minutes or until a cake tester inserted in the center comes out clean. Cool in the pan for 10 minutes, then turn out onto a rack to cool completely.

Peanut Butter Bread

Serves 8 to 10

1 cup firmly packed brown sugar

\(^1\)3 cup chunky peanut butter

1 large egg

1\(^3\)4 cups all-purpose flour

1 teaspoon baking soda

1 teaspoon salt

1 cup buttermilk

- **1.** Preheat the oven to 350°F. Grease a $9 \times 5 \times 2^{1/2}$ -inch loaf pan.
- 2. In a large bowl, cream together the brown sugar and peanut butter. Beat in the egg. In a separate bowl, combine ³/₄ cup of the flour, the baking soda, and salt and add to the creamed mixture. Add the buttermilk to the mixture alternately with the remaining 1 cup flour, mixing well after each addition. Pour the batter into the prepared pan and bake for about 60 minutes or until a cake tester inserted in the center comes out clean. Cool in the pan for 10 minutes, then turn out onto a rack to cool completely.

Carrot Cake Bread

Serves 8 to 10

1½ cups sugar
½ teaspoon ground cloves
1 teaspoon ground cinnamon
1 teaspoon ground nutmeg
1 cup raisins
1½ cups grated carrot
2 tablespoons butter
1⅓ cups water
2 cups all-purpose flour
2 teaspoons baking soda
⅓ teaspoon salt

- **1.** Preheat the oven to 350°F. Grease a $9 \times 5 \times 2^{1/2}$ -inch loaf pan.
- 2. In a 4-quart saucepan over medium heat, combine the sugar, cloves, cinnamon, nutmeg, raisins, carrots, butter, and water. Bring to a boil, then reduce the heat and simmer for 5 minutes. Remove from the heat, transfer to a large bowl, and cool to room temperature. In a separate bowl, combine the flour, baking soda, and salt. Add the dry ingredients to the cooled carrot mixture and stir well. Pour the batter into the prepared pan and bake for about 75 minutes or until a cake tester inserted in the center comes out clean. Cool in the pan for 10 minutes, then turn out onto a rack to cool completely.

Old-Fashioned Corn Bread

Serves 8 to 10

1 cup all-purpose flour

1½ cups yellow cornmeal

½ cup cultured buttermilk powder

¾ teaspoon baking soda

1 teaspoon salt

2 large eggs, beaten

1½ cups water

3 tablespoons solid vegetable shortening, melted

- 1. Preheat the oven to 425° F. Grease an 8-inch square pan.
- 2. In a large bowl, combine the flour, cornmeal, buttermilk powder, baking soda, and salt. In a separate bowl, using an electric mixer, beat the eggs, water, and melted shortening. Add the liquid mixture to the dry ingredients, stirring until just smooth. Pour the batter into the prepared pan and bake for about 25 minutes or until a cake tester inserted in the center comes out clean. Serve hot.

Nouvelle Corn Bread

Serves 10 to 12

2½ cups all-purpose flour
1 cup yellow cornmeal
2 teaspoons baking soda
1 teaspoon salt
¾ cup shredded whole milk mozzarella cheese
2 large eggs, beaten
1½ cups milk
⅓ cup balsamic vinegar
⅓ cup olive oil

- **1**. Preheat the oven to 350°F. Grease a $9 \times 5 \times 2^{1/2}$ -inch loaf pan.
- 2. In a large bowl, combine the flour, cornmeal, baking soda, and salt, then stir in the mozzarella to fully incorporate. In a separate bowl, whisk together the eggs, milk, vinegar, and oil. Add the liquid mixture to the dry ingredients and stir until just smooth. Pour the batter into the prepared pan and bake for about 45 minutes or until a cake tester inserted in the center comes out clean. Cool in the pan for 10 minutes, then turn out onto to a rack to cool completely.

Buttermilk-Amaranth Bread

Serves 10 to 12

2½ cups all-purpose flour
1½ cups amaranth flour
¾ cup cultured buttermilk powder
⅓ cup sugar
2 teaspoons baking soda
2 large eggs, beaten
2 cups water
½ cup corn oil

- **1.** Preheat the oven to 350°F. Grease a $9 \times 5 \times 2^{1/2}$ -inch loaf pan.
- 2. In a large bowl, combine the all-purpose flour, amaranth flour, buttermilk powder, and sugar. In a separate bowl, whisk together the eggs, water, and oil. Add the liquid mixture to the dry ingredients and stir until just smooth. Pour the batter into the prepared pan and bake for about 60 minutes or until a cake tester inserted in the center comes out clean. Cool in the pan for 10 minutes, then turn out onto a rack to cool completely.

Pumpkin Bread

Serves 10 to 12

3 cups all-purpose flour
1 cup sugar
2 teaspoons baking soda
1/4 teaspoon cream of tartar
1/2 teaspoon salt
2 teaspoons ground cinnamon
1 teaspoon ground nutmeg
1 cup raisins
1 cup chopped roasted cashews
3 large eggs, beaten
11/2 cups canned pumpkin pie filling
1/4 cup corn oil
1 cup water

- **1.** Preheat the oven to 350°F. Grease a $9 \times 5 \times 2^{1/2}$ -inch loaf pan.
- 2. In a large bowl, combine the flour, sugar, baking soda, cream of tartar, salt, cinnamon, and nutmeg, then stir in the raisins and cashews. In a separate bowl using an electric mixer, beat the eggs, pumpkin, and oil. Add the water and beat briefly, until well blended. Stir the liquid mixture into the dry ingredients and stir until just smooth. Pour the batter into the prepared pan and bake for about 75 minutes or until a cake tester inserted in the center comes out clean. Cool in the pan for 10 minutes, then turn out onto a rack to cool completely.

Harvest Bread

Serves 10 to 12

The ketchup, with its tomatoes and vinegar, is a convenient source of acid to work with the baking soda.

2½ cups all-purpose flour
½ cup yellow cornmeal
½ cup quick-cooking oats
1 cup brown sugar
2 teaspoons baking soda
2 teaspoons ground cinnamon
1 cup raisins
2 large eggs, beaten
½ cup canned pumpkin pie filling
½ cup tomato ketchup
¼ cup corn oil
1½ cups apple juice

- **1**. Preheat the oven to 350°F. Grease a $9 \times 5 \times 2\frac{1}{2}$ -inch loaf pan.
- 2. In a large bowl, combine the flour, cornmeal, oats, brown sugar, baking soda, and cinnamon, then stir in the raisins. In a separate bowl using an electric mixer, beat the eggs, pumpkin, ketchup, and oil. Add the apple juice and beat briefly, until well blended. Stir the liquid mixture into the dry ingredients and stir until just smooth. Pour the batter into the prepared pan and bake for about 75 minutes or until a cake tester inserted in the center comes out clean. Cool in the pan for 10 minutes, then turn out onto a rack to cool completely.

Zucchini Bread

Serves 10 to 12

2 cups all-purpose flour

1½ cups sugar

2¼ teaspoons baking soda

¼ teaspoon cream of tartar

1 tablespoon ground cinnamon

1 teaspoon ground nutmeg

1 cup raisins

2 cups coarsely grated peeled zucchini

1 cup corn oil

2 teaspoons vanilla extract

3 large eggs, beaten

- **1.** Preheat the oven to 375°F. Grease a $9 \times 5 \times 2^{1/2}$ -inch loaf pan.
- 2. In a large bowl, combine the flour, sugar, baking soda, cream of tartar, cinnamon, and nutmeg, then stir in the raisins and zucchini. In a separate bowl, whisk together the eggs, oil, and vanilla. Add the liquid mixture to the dry ingredients and stir until just smooth. Pour the batter into the prepared pan and bake for about 70 minutes or until a cake tester inserted in the center comes out clean. Cool in the pan for 10 minutes, then turn out onto a rack to cool completely.

Simple Soda Bread

Serves 8 to 12

4 cups all-purpose flour

1/2 cup cultured buttermilk powder
1 tablespoon sugar
2 teaspoons baking soda
1 teaspoon salt
1 cup raisins
11/2 cups cold water
1/3 cup olive oil

- 1. Preheat the oven to 350°F. Grease a baking sheet.
- 2. In a large bowl, combine the flour, buttermilk powder, sugar, baking soda, and salt, then stir in the raisins. Add the water and stir to form a soft dough, then knead in the oil until well blended. Turn onto a lightly floured surface and knead to form a smooth ball. Pat by hand onto the prepared baking sheet to about 1½-inch thickness. Using a sharp knife, score the loaf 4 times. Bake for 45 minutes or until the bread is lightly browned and a cake tester inserted in the center comes out clean. Remove to a rack to cool slightly. Serve warm with butter.

Apple-Nut Muffins

Makes 6 muffins

1½ cups all-purpose flour
½ cup quick-cooking oats
¾ cup brown sugar
1 teaspoon baking soda
2 teaspoons cream of tartar
½ teaspoon salt
1 teaspoon ground cinnamon
¼ teaspoon ground nutmeg
1 cup peeled, cored, and coarsely chopped apple
½ cup chopped walnuts
½ cup raisins
2 large eggs, beaten
¼ cup cold milk
½ cup (1 stick) margarine, melted and cooled

- **1.** Preheat the oven to 400°F. Lightly grease six 4-inch muffin cups.
- 2. In a large bowl, combine the flour, oats, brown sugar, baking soda, cream of tartar, salt, cinnamon, and nutmeg, then stir in the apples, walnuts, and raisins. In a separate bowl, whisk together the eggs, milk, and melted margarine. Add the liquid mixture to the dry ingredients and stir until just blended. Scoop the batter into the prepared muffin cups about two-thirds full. Bake for about 15 minutes or until a cake tester inserted in the center of a muffin comes out clean. Cool in the pan for 5 minutes, then turn out onto a rack to cool slightly before serving.

Sweet Potato Muffins

Makes 6 muffins

13/4 cups all-purpose flour
11/2 cups sugar
1 teaspoon baking soda
1/2 teaspoon salt
1 teaspoon ground cinnamon
1/2 teaspoon ground nutmeg
1/4 teaspoon ground allspice
1/4 teaspoon ground allspice
1/2 cup raisins
1 cup mashed sweet potatoes
2 large eggs, beaten
1/2 cup canola oil
1/2 cup water

- 1. Preheat the oven to 350°F. Lightly grease six 4-inch muffin cups.
- 2. In a large bowl, combine the flour, sugar, baking soda, salt, cinnamon, nutmeg, cloves, and allspice, then stir in the raisins. In a separate bowl, blend together the mashed sweet potatoes, eggs, oil, and water. Add the liquid mixture to the dry ingredients and stir together until just blended. Scoop the batter into the prepared muffin cups about two-thirds full. Bake for about 25 minutes or until a cake tester inserted in the center of a muffin comes out clean. Cool in the pan for 5 minutes, then turn out onto a rack to cool slightly before serving.

Jelly Muffins

Makes 6 muffins

1½ cups all-purpose flour
3 tablespoons sugar
½ teaspoon baking soda
½ teaspoon salt
1 cup buttermilk
3 tablespoons butter or margarine, melted and cooled
6 tablespoons jelly, for filling the muffins

- **1.** Preheat the oven to 375°F. Lightly grease six 4-inch muffin cups.
- 2. In a large bowl, combine the flour, sugar, baking soda, and salt. Add the buttermilk and melted butter and stir until just blended. Scoop the batter into the prepared muffin cups one-third full. Place 1 tablespoon of jelly in the center of each muffin, then fill the cups with the remaining batter about two-thirds full. Bake for 20 to 25 minutes or until a cake tester inserted in the center of a muffin comes out clean. Cool in the pan for 5 minutes, then turn out onto a rack to cool slightly before serving.

Zucchini Muffins

Makes 6 muffins

2 cups all-purpose flour

3/4 cup sugar

3/4 teaspoon baking soda

3/4 teaspoon baking powder

3/4 teaspoon salt

1 teaspoon ground cinnamon

1 teaspoon ground nutmeg

1 cup coarsely grated zucchini

1/2 cup raisins

1/2 cup chopped walnuts

3 large eggs, beaten

3/4 cup corn oil

2 teaspoons vanilla extract

- 1. Preheat the oven to 375°F. Grease six 4-inch muffin cups.
- 2. In a large bowl, combine the flour, sugar, baking soda, baking powder, salt, cinnamon, and nutmeg, then stir in the zucchini, raisins, and walnuts. In a separate bowl, whisk together the eggs, oil, and vanilla. Add the liquid mixture to the dry ingredients and stir until just blended. Scoop the batter into the prepared muffin cups about two-thirds full. Bake for about 25 minutes or until a cake tester inserted in the center of a muffin comes out clean. Cool in the pan for 5 minutes, then turn out onto a rack to cool slightly before serving.

Gruity Fiber Muffins

Makes 6 to 8 muffins

2 cups all-purpose flour
1½ cups sugar
2 teaspoons baking soda
½ teaspoon salt
1 tablespoon ground cinnamon
2 cups shredded carrots
1 cup shredded zucchini
1 apple, peeled, cored, and grated
¾ cup golden raisins
¾ cup shredded unsweetened coconut
½ cup chopped pecans
1¼ teaspoons grated orange peel
3 large eggs, beaten
1 cup peanut oil
1 teaspoon vanilla extract

- 1. Preheat the oven to 375°F. Lightly grease six to eight 4-inch muffin cups.
- 2. In a large bowl, combine the flour, sugar, baking soda, salt, and cinnamon, then stir in the carrots, zucchini, apple, raisins, coconut, pecans, and orange peel. In a separate bowl, beat the eggs with the oil, then add the vanilla. Add the liquid mixture to the dry ingredients and stir until just blended. Scoop the batter into the prepared muffin cups about two-thirds full. Bake for 20 to 25 minutes or until a cake tester inserted in the center of a muffin comes out clean. Cool in the pan for 5 minutes, then turn out onto a rack to cool slightly before serving.

Yogurt-Berry Muffins

Makes 6 muffins

1½ cups unbleached flour

1/4 teaspoon baking soda

½ teaspoon cream of tartar

1/4 teaspoon salt

½ cup (1 stick) butter, softened

½ cup sugar

½ teaspoon vanilla extract

2 large eggs

1/4 cup plain yogurt

²/₃ cup hulled and chopped fresh strawberries or 1 cup blueberries

- **1.** Preheat the oven to 400°F. Lightly grease six 4-inch muffin cups.
- 2. In a large bowl, combine the flour, baking soda, cream of tartar, and salt. In a separate bowl, cream together the butter and sugar until fluffy. Add the vanilla and then the eggs, one at a time, beating well after each addition. Alternately add dry mixture and the yogurt to the creamed mixture, beating well after each addition. Gently fold in the berries. Scoop the batter into the prepared muffin cups about two-thirds full. Bake for about 25 minutes or until a cake tester inserted in the center of a muffin comes out clean. Cool in the pan for 5 minutes, then turn out onto a rack to cool slightly before serving.

Shoofly Muffins

Makes 6 muffins

2 cups unbleached flour 1 cup dark brown sugar ½ cup (1 stick) butter or margarine, softened ½ cup molasses 1 cup boiling water 1 teaspoon baking soda

- 1. Preheat the oven to $425^{\circ}F$. Lightly grease six 4-inch muffin cups.
- 2. In a large bowl, combine the flour, brown sugar, and butter until the consistency of fine crumbs. Reserve ³/₄ cup of this mixture for the topping. In a separate bowl, combine the molasses, boiling water, and baking soda; the mixture will foam. Add the dry mixture to the liquid ingredients and stir until just blended. The batter will be thin. Pour the batter into the prepared muffin cups about two-thirds full and sprinkle the top of each with 2 tablespoons of the crumb mixture. Bake for about 15 minutes or until a cake tester inserted in the center of a muffin comes out clean. Cool in the pan for 5 minutes, then turn out onto a rack to cool slightly before serving.

Brown Bread Muffins

Makes 6 muffins

2 cups whole wheat flour
²/3 cup all-purpose flour
²/3 cup cultured buttermilk powder
²/3 cup brown sugar
2 teaspoons baking soda
1 teaspoon ground nutmeg
³/4 cup raisins
2 cups water

- **1.** Preheat the oven to 350°F. Grease six 4-inch muffin cups.
- 2. In a large bowl, combine the whole wheat flour, all-purpose flour, buttermilk powder, brown sugar, baking soda, and nutmeg, then stir in the raisins. Add the water and mix until just smooth. Scoop the batter into the prepared muffin cups about two-thirds full. Bake for about 35 minutes or until a cake tester inserted in the center of a muffin comes out clean. Cool in the pan for 5 minutes, then turn out onto a rack to cool slightly before serving.

Banana-Oat-Raisin Muffins

Makes 12 muffins

1½ cups quick-cooking oats
½ cup all-purpose flour
½ cup whole wheat flour
1 teaspoon baking soda
1 teaspoon salt
1 cup raisins
1 cup mashed ripe banana
1 large egg, beaten
1 cup milk
¼ cup corn oil
2 teaspoons vanilla extract

- 1. Preheat the oven to 400°F . Grease twelve $2\frac{1}{2}$ -inch muffin cups.
- 2. In a large bowl, combine the oats, all-purpose flour, whole wheat flour, baking soda, baking powder, and salt, then stir in the raisins. In a separate bowl, blend together the banana, egg, milk, oil, and vanilla. Add the liquid mixture to the dry ingredients and stir until just blended. Scoop the batter into the prepared muffin cups two-thirds full. Bake for about 20 minutes or until a cake tester inserted in center of a muffin comes out clean. Cool in the pan for 5 minutes, then turn out onto a rack to cool slightly before serving.

COOKIES

Big and Easy Oatmeal Cookies

Makes 1½ to 2 dozen

3 cups quick-cooking oats
1 cup all-purpose flour
1½ cups brown sugar
1 teaspoon baking soda
1 cup raisins
1 large egg, beaten
¼ cup cold water
¾ cup (1½ sticks) margarine, melted and cooled
2 teaspoons vanilla extract

- 1. Preheat the oven to 350°F. Lightly grease 2 cookie sheets.
- 2. In a large bowl, combine the oats, flour, brown sugar, and baking soda, then stir in the raisins. In a separate bowl, whisk together the egg, cold water, melted margarine, and vanilla. Add the liquid mixture to the dry ingredients and stir until smooth. Shape the dough with floured hands into $1\frac{1}{2}$ -inch balls and place them 2 inches apart on the prepared cookie sheets. Bake for 18 to 20 minutes or until lightly browned. Cool on the cookie sheets for 3 minutes, then transfer to racks to cool completely.

Birthday Cookie

Serves 10 to 12
Everyone will love this unique alternative to
birthday cake.

1½ cups all-purpose flour
¾ cup brown sugar
1 teaspoon baking soda
½ teaspoon salt
1½ cups semisweet chocolate chips, plus more for topping
1 large egg, beaten
½ cup (1 stick) margarine, melted and cooled
¼ cup corn syrup
2 teaspoons vanilla extract

- 1. In a large bowl, combine the flour, brown sugar, baking soda, and salt, then stir in the chocolate chips. In a separate bowl, whisk together the egg, margarine, corn syrup, and vanilla. Add the liquid mixture to the dry ingredients and stir until smooth. Cover with plastic and refrigerate for at least 1 hour.
- 2. Preheat the oven to 325°F. Grease a 12-inch round foil baking pan and spread the dough to within 1½ inches of its edge. Spell out a birthday greeting with chocolate chips lightly pressed into the surface. Place the pan on a cookie sheet and bake for about 30 minutes or until the edges are firm. Place the pan on a rack and cool completely.

Chocolate Chip Redux

Makes 3 to 4 dozen

Mayonnaise is a blend of oil, egg, and
vinegar—a convenient source of shortening,
protein, and baking acid.

3¾ cups all-purpose flour 2 cups brown sugar 2½ teaspoons baking soda ¾ teaspoon salt 2 cups semisweet chocolate chips ¾ cup (1½ sticks) margarine, melted 1½ cups mayonnaise

- **1.** Preheat the oven to 350°F. Lightly grease 2 cookie sheets.
- 2. In a large bowl, combine the flour, brown sugar, baking soda, and salt, then stir in the chocolate chips. In a separate bowl using an electric mixer, beat the melted margarine with the mayonnaise, then add the dry mixture. Beat briefly, about 1 minute, to form a coarse dough. Shape the dough into 1½-inch balls and place 2 inches apart on the prepared cookie sheets. Bake for about 15 minutes or until lightly browned. Cool on the cookie sheets for 3 minutes, then transfer to racks to cool completely.

Orange-Apricot Cookies

Makes 3 to 4 dozen

1 cup all-purpose flour
3/4 cup whole wheat flour
1/4 cup sugar
1/2 teaspoon baking soda
1/4 teaspoon salt
1/2 teaspoon ground cinnamon
3/4 cup chopped dried apricots
1 teaspoon grated orange zest
1 large egg, beaten
1/2 cup fresh orange juice
1/4 cup corn oil

1. Preheat the oven to 375°F.

2. In a large bowl, combine the all-purpose flour, whole wheat flour, sugar, baking soda, salt, and cinnamon, then stir in the apricots and orange zest. In a separate bowl, whisk together the egg, orange juice, and oil. Add the liquid mixture to the dry ingredients and stir until smooth. Drop by tablespoonfuls about 1 inch apart onto ungreased cookie sheets. Bake for about 10 minutes or until lightly browned. Cool on the cookie sheets for 3 minutes, then transfer to racks to cool completely.

Ricotta Cookies

Makes about 2 dozen

Cookies

2 cups (4 sticks) margarine or butter

2 cups sugar

3 large eggs

1 pound ricotta cheese

2 teaspoons vanilla extract

1 teaspoon salt

4 cups all-purpose flour

1 teaspoon baking soda

Sugar Icing

2 tablespoons margarine or butter

2 tablespoons milk

2 cups sifted confectioners' sugar

Food coloring (optional)

- 1. Preheat the oven to 350°F.
- 2. In a large bowl using an electric mixer, cream together the butter and sugar until light and fluffy. In a separate bowl, whisk together the eggs, ricotta, vanilla, and salt, then add to the creamed mixture. In another bowl, combine the flour and baking soda and blend into the batter to form a soft dough. Shape the dough into 1-inch balls and place on ungreased cookie sheets 2 inches apart. Bake for 10 to 12 minutes, but don't let them brown. Cool on the cookie sheets for 2 minutes, then transfer to racks to cool completely.
- **3.** While the cookies are cooling, make the icing: Combine the margarine, milk, and confectioners' sugar in a medium saucepan over low heat and stir until smooth. Add more milk if needed and a few drops of food coloring if desired. Spread the icing over the cooled cookies in a thin layer.

Peanut Butter-Chocolate Cookies

Makes about 2 dozen

11 tablespoons margarine, softened
3/4 cup sugar
2 large eggs, beaten
1 teaspoon vanilla extract
6 ounces semisweet chocolate, melted
11/2 cups all-purpose flour
2 cups quick-cooking oats
1 teaspoon baking soda
2 cups peanut butter chips

- 1. In a large bowl using an electric mixer, cream together the margarine and sugar. Add the eggs and vanilla and beat until smooth. Add the melted chocolate and beat until smooth. In a separate bowl, combine the flour, oats, and baking soda. Gradually beat the dry ingredients into the liquid mixture and stir until smooth. Stir in the peanut butter chips. Cover with plastic and refrigerate for at least 1 hour.
- 2. Preheat the oven to 350°F. Lightly grease 2 cookie sheets. Shape the dough into 1½-inch balls and place them 2 inches apart on the prepared cookie sheets. Bake for about 15 minutes or until lightly browned. Cool on the cookie sheets for 3 minutes, then transfer to racks to cool completely.

Chocolate-Peanut Butter Cookies

Makes about 2 dozen

1 cup (2 sticks) margarine, softened

1½ cups brown sugar

2 cups chunky peanut butter

2 large eggs, beaten

2 teaspoons butter-flavor extract

2 cups all-purpose flour

2 teaspoons baking soda

1/4 teaspoon salt

2 cups semisweet chocolate chips

- 1. In a large bowl using an electric mixer, cream together the margarine, brown sugar, and peanut butter. Add the eggs and butter extract and beat until smooth. In a separate bowl, combine the flour, baking soda, and salt. Gradually beat the dry ingredients into the liquid mixture and stir until smooth. Stir in the chocolate chips. Cover with plastic and refrigerate for at least 1 hour.
- 2. Preheat the oven to 375° F. Lightly grease 2 cookie sheets. Shape the dough into $1\frac{1}{2}$ -inch balls and place them 2 inches apart on the prepared cookie sheets. Bake for about 15 minutes or until lightly browned. Cool on the cookie sheets for 3 minutes, then transfer to racks to cool completely.

Snowman Cookies

Makes about 2 dozen

3/4 cup (11/2 sticks) butter, softened 8 ounces cream cheese, softened 1 cup confectioners' sugar, plus more for sprinkling 1/2 teaspoon vanilla extract 21/4 cups all-purpose flour 1/2 teaspoon baking soda Miniature peanut butter cups, for decorating

- 1. Preheat the oven to 325°F.
- 2. In a large bowl, cream together the butter, cream cheese, confectioners' sugar, and vanilla. Add the flour and baking soda and mix well. Cover with plastic and refrigerate for 30 minutes.
- 3. Shape two pieces of the dough into two small balls, about 1 to $1\frac{1}{2}$ inches, one slightly larger than the other. Slightly overlap the balls on an ungreased cookie sheet, then flatten them with the bottom of a glass. Repeat with the remaining dough. Bake for 18 to 20 minutes or until light golden brown. Cool on the cookie sheet for 2 minutes, then transfer to racks to cool completely. Decorate the snowmen with icing as desired, and sprinkle with sifted confectioners' sugar. Cut the miniature peanut butter cups in half to use as hats.

Egg Nog Cookies

Makes about 2 dozen

1/2 cup (1 stick) butter, softened
1 cup sugar
1/2 cup egg nog
1/4 teaspoon ground nutmeg
1/2 teaspoon baking soda
About 23/4 cups all-purpose flour
Colored sugar, for sprinkling (optional)

- **1.** Preheat the oven to 375°F. Lightly grease a cookie sheet.
- 2. In a large bowl, cream together the butter and sugar until fluffy, then add the egg nog, nutmeg, and baking soda. Mix well. Stir in enough flour to make stiff dough. Roll into a ball, cover with plastic, and chill for 1 to 2 hours. Remove the chilled dough from the refrigerator and roll it out ½-s-inch thick on a lightly floured surface. Cut with cookie cutters. Place the cookies on a cookie sheet and bake for 6 to 8 minutes or until lightly browned. Cool on the cookie sheet for 2 minutes, then transfer to racks to cool completely. Sprinkle with colored sugar while the cookies are still hot, if desired.

Graham Crackers

Makes about 2 dozen

1 cup (2 sticks) butter
4 cups whole wheat or graham flour
½ cup honey
1 teaspoon baking soda
1 teaspoon cream of tartar
1 large egg, lightly beaten
About ½ cup hot water

1. Preheat the oven to 350°F.

2. In a large bowl, cut the butter into the flour until the mixture is the consistency of coarse meal. Blend in the honey, baking soda, cream of tartar, egg, and enough hot water to make a dough that can be rolled like pastry. Roll the dough out ½s-inch thick on a lightly floured surface. Cut into squares with a knife. Place the crackers on ungreased cookie sheets and bake for 15 to 20 minutes or until firm. Cool on the cookie sheets for 4 minutes, then transfer to racks to cool completely.

Animal Crackers

Makes about 2 dozen

1/2 cup rolled oats
3/4 cup all-purpose flour
1/4 teaspoon baking soda
1/8 teaspoon salt
2 teaspoons honey
1/4 cup (1/2 stick) butter
4 tablespoons buttermilk

- 1. Preheat the oven to 400°F.
- 2. Grind the oats in a blender until you have a fine powder. Transfer the ground oats to a large bowl and add the flour, baking soda, and salt. Mix well. Add the honey, then cut in the butter. Add the buttermilk and stir until the dough forms a ball. Roll the dough out ½-inch thick on a lightly floured surface. Cut with animal-shaped cookie cutters. Place the crackers on ungreased cookie sheets and bake until lightly browned, 10 to 12 minutes. Cool on the cookie sheet for 4 minutes, then transfer to racks to cool completely.

Bran-Apple Bars

Makes 8 to 10 bars

1 cup all-bran cereal

1/2 cup skim milk
1 cup all-purpose flour

1/2 teaspoon baking soda

1/2 teaspoon ground cinnamon

1/4 teaspoon ground nutmeg
5 tablespoons margarine, softened

1/2 cup brown sugar
2 large egg whites
1 cup peeled, cored, and finely chopped apple

- 1. Preheat the oven to 350°F. Lightly grease a 9-inch square baking pan.
- 2. In a small bowl, soak the bran in the milk until the milk is absorbed. In a medium bowl, combine the flour, baking soda, cinnamon, and nutmeg. In a separate bowl using an electric mixer, cream together the margarine and brown sugar. Add the egg whites and beat well. Add the dry ingredients and stir until just smooth. Stir in the bran mixture and the apples. Pour the batter into the prepared baking pan. Bake for 30 minutes or until a cake tester inserted in the center comes out clean. Place the pan on a rack to cool completely before removing from the pan.

BREAKFAST

Orange-Raisin Scones

Makes about 2 dozen

3 cups all-purpose flour

½ cup sugar
2 teaspoons baking soda
½ cup (1 stick) margarine, chilled and cut into pieces
1 cup raisins
1 large egg, beaten
½ cup orange juice

- **1.** Preheat the oven to 350°F. Lightly grease 2 baking sheets.
- 2. In a large bowl, combine the flour, sugar, and baking soda. Using an electric mixer, cut in the margarine until the mixture resembles coarse meal. Stir in the raisins. In a separate bowl, whisk the egg with the orange juice. Add the liquid mixture to the dry ingredients and mix until just combined. Gather the dough into a ball and roll the dough out on a lightly floured surface ½-inch thick. Cut the scones with a 3-inch round cutter, gathering the scraps and re-rolling the dough. Place the scones on the baking sheets about ½ inch apart. Bake for about 15 minutes or until lightly browned. Serve hot.

Cinnamon Drop Biscuits

Makes about 2 dozen

2 cups all-purpose flour
3 tablespoons sugar
½ teaspoon baking soda
½ teaspoon salt
1 teaspoon ground cinnamon
4 tablespoons butter-flavored shortening
½ cup buttermilk
1 large egg, beaten
Confectioners' sugar, for sprinkling

1. Preheat the oven to 425°F.

2. In a large bowl, combine the flour, sugar, baking soda, salt, and cinnamon. Using a pastry cutter, cut in the shortening until the mixture resembles coarse meal. In a separate bowl, whisk together the egg and milk. Add the liquid mixture to the dry ingredients and stir vigorously just a few times until the mixture forms a soft dough that clings to sides of the bowl. Drop by heaping tablespoonfuls onto an ungreased cookie sheet. Sprinkle with confectioners' sugar. Bake for 10 to 12 minutes or until lightly browned. Serve hot or transfer to a rack to cool.

Graham Buttermilk Pancakes

Makes twenty to twenty-four 4-inch pancakes

2 cups all-purpose flour

½ cup finely crushed graham crackers (from 3 whole crackers)

½ cup cultured buttermilk powder

2 tablespoons sugar

2 teaspoons baking soda

½ teaspoon salt

2 large eggs, beaten

2 cups water

4 tablespoons corn oil

2 teaspoons vanilla extract

- 1. Grease and preheat a griddle.
- 2. In a large bowl, combine the flour, crushed graham crackers, buttermilk powder, sugar, baking soda, and salt. In a separate bowl, whisk together the eggs, water, oil, and vanilla. Add the liquid mixture to the dry ingredients and quickly stir until just smooth. Pour about ½ cupfuls of batter onto the griddle. Cook on one side until bubbles rise to the top and the underside is lightly browned. Flip and cook until lightly browned on the other side. Repeat with the remaining batter and serve immediately.

Cornmeal Pancakes

Makes twenty to twenty-four 4-inch pancakes

1 cup all-purpose flour
1 cup yellow cornmeal
1/3 cup instant nonfat milk powder
2 tablespoons sugar
21/2 teaspoons baking soda
1/2 teaspoon cream of tartar
1/2 teaspoon salt
3 large eggs, beaten
1 cup water
3 tablespoons margarine, melted and cooled

- 1. Grease and preheat a griddle.
- 2. In a large bowl, combine the flour, cornmeal, milk powder, sugar, baking soda, cream of tartar, and salt. In a separate bowl, whisk together the eggs, water, and margarine. Add the liquid mixture to the dry ingredients and quickly stir until just smooth. Pour about ½ cupfuls of batter onto the griddle. Cook on one side until bubbles rise to the top and the underside is lightly browned. Flip and ćook until lightly browned on the other side. Repeat with the remaining batter and serve immediately.

Pumpkin Pancakes

Makes ten to twelve 4-inch pancakes

1 cup all-purpose flour
2 tablespoons sugar
1/4 teaspoon baking soda
1/4 teaspoon ground cinnamon
1/8 teaspoon ground ginger
1/8 teaspoon ground nutmeg
1 large egg, well-beaten
1/2 cup canned pumpkin
11/4 cups milk
2 tablespoons shortening, melted and cooled

- 1. Grease and preheat a griddle.
- 2. In a large bowl, combine the flour, sugar, baking soda, cinnamon, ginger, and nutmeg. In a separate bowl, whisk together the egg, pumpkin, milk, and shortening. Add the liquid mixture to the dry ingredients and quickly stir until just smooth. Pour about ½ cupfuls of batter onto the griddle. Cook on one side until bubbles rise to the top and the underside is lightly browned. Flip and cook until lightly browned on the other side. Repeat with the remaining batter and serve immediately.

Pancake Soufflé

Makes ten to twelve 4-inch pancakes

1/2 cup all-purpose flour
1/4 cup sugar
1 teaspoon baking soda
1 teaspoon salt
6 large eggs separated, at room temperature
1 cup sour cream

- 1. Grease and preheat a griddle.
- 2. In a large bowl, combine the flour, sugar, baking soda, and salt. Add the egg yolks and sour cream to the dry ingredients and mix well. In a separate bowl, using an electric mixer, beat the egg whites until stiff and gently fold into the batter. Pour about ½ cupful of batter onto the griddle. Cook on one side until bubbles rise to the top and the underside is lightly browned. Flip and cook until lightly browned on the other side. Repeat with the remaining batter and serve immediately.

Buckwheat Pancakes

Makes ten to twelve 4-inch pancakes

1/2 cup all-purpose flour
1/3 cup buckwheat flour
1/4 teaspoon baking soda
1/4 teaspoon salt
1 large egg, beaten
1 1/4 cups buttermilk
3 tablespoons butter or margarine, melted

- 1. Grease and preheat a griddle.
- 2. In a large bowl, combine the all-purpose flour, buckwheat flour, baking soda, and salt. In a separate bowl, whisk together the egg, buttermilk, and butter. Add the liquid mixture to the dry ingredients and quickly stir until just smooth. Pour about ½ cupfuls of batter onto the griddle. Cook on one side until bubbles rise to the top and the underside is lightly browned. Flip and cook until lightly browned on the other side. Repeat with the remaining batter and serve immediately.

Waffles

Makes 16 to 20

2 cups all-purpose flour
½ teaspoon baking soda
½ teaspoon salt
4 large eggs
¼ cup sugar
2 cups plain yogurt or sour cream

- 1. Grease and preheat a waffle iron.
- 2. In a large bowl, combine the flour, baking soda, and salt. In a separate bowl, beat the eggs with the sugar using an electric mixer until thickened. Add the dry mixture to the eggs alternately with the yogurt, beginning and ending with the dry mixture. Stir until just smooth. Prepare the waffles according to the manufacturer's instructions.

Gingerbread Waffles

Makes 16 to 20

2½ cups all-purpose flour
1½ teaspoons baking soda
2 teaspoons ground ginger
1 large egg, separated
1 cup light molasses
½ cup skim milk
⅓ cup butter or margarine, melted and cooled

- 1. Grease and preheat a waffle iron.
- 2. In a large bowl, combine the flour, baking soda, and ginger. In a separate bowl, whisk together the egg yolk, molasses, milk, and melted butter. Add the liquid mixture to the dry ingredients and mix well. In another bowl, using an electric mixer, beat the egg whites until stiff and gently fold into the batter. Prepare the waffles according to the manufacturer's instructions.

English Muffin Loaves

Serves 10 to 12

Cornmeal, for sprinkling 6 cups all-purpose flour 2 packages active dry yeast 1 tablespoon sugar 1/4 teaspoon baking soda 2 teaspoons salt 21/2 cups low-fat milk

- **1.** Grease two $8\frac{1}{2} \times 4\frac{1}{2}$ -inch pans and sprinkle them with cornmeal.
- 2. In a large bowl, combine 3 cups of the flour with the yeast, sugar, baking soda, and salt. Heat the milk in a small saucepan over low heat until very warm (120°F to 130°F). Do not boil. Add the milk to the dry mixture and beat well. Stir in the remaining flour to make a stiff batter and spoon into the prepared pans. Cover with a kitchen towel and let rise in warm area for 45 minutes or until doubled.
- **3.** While the dough is rising, preheat the oven to 400°F. Bake the loaves for 25 minutes or until lightly browned. Immediately remove the loaves from the pans and cool on a rack to room temperature.

Easy Brown Bread

Serves 8 to 10

1 cup all-purpose flour 2 cups whole wheat flour ½ cup sugar 1 teaspoon baking soda ½ teaspoon salt ½ cup molasses 1½ cups milk ¾ cup raisins

- **1.** Preheat the oven to 375°F. Grease a 9×5 2½-inch loaf pan.
- 2. In a large bowl, combine the all-purpose flour, whole wheat flour, sugar, baking soda, and salt. In a separate bowl, whisk together the molasses and milk. Add the liquid mixture to the dry ingredients and stir until just smooth. Fold in the raisins. Pour the batter into the prepared pan and bake for 60 minutes or until a cake tester inserted in the center comes out clean. Cool in the pan for 10 minutes, then turn out onto a rack to cool completely.

Graham Bread

Serves 8 to 10

1 cup all-purpose flour
2 cups graham flour
½ cup cornmeal
½ cup sugar
1 teaspoon baking soda
1 teaspoon salt
2 cups buttermilk
½ cup molasses

- **1.** Preheat the oven to 350°F. Grease a $9 \times 5 \times 2^{1/2}$ -inch loaf pan.
- 2. In a large bowl, combine the all-purpose flour, graham flour, cornmeal, sugar, baking soda, and salt. In a separate bowl, whisk together the buttermilk and molasses. Add the liquid mixture to the dry ingredients and stir until just smooth. Pour the batter into the prepared pan and bake for 90 minutes or until a cake tester inserted in the center comes out clean. Cool in the pan for 10 minutes, then turn out onto a rack to cool completely.

Junnel Cakes

Serves 10 to 12

Vegetable oil, for frying
11/4 cups all-purpose flour
2 tablespoons sugar
1 teaspoon baking soda
3/4 teaspoon baking powder
1/4 teaspoon salt
1 large egg, beaten
3/4 cup milk
Confectioners' sugar, for sprinkling

Heat ½ inch oil in a large skillet. In a large bowl, combine the flour, sugar, baking soda, baking powder, and salt. In a separate bowl, whisk together the egg and milk. Add the wet mixture to the dry ingredients and stir until just smooth. Using a funnel with at least a ¾-inch opening and using your finger to cover the bottom, dribble about ½ cup batter at a time into the center of the skillet in a slow, overlapping spiral pattern. Fry 2 minutes or until golden brown on both sides, turning once. Drain on paper towels and sprinkle with confectioners' sugar. Serve hot with pancake syrup.

CAKES

Cranberry Cake

Serves 8 to 12

2½ cups all-purpose flour

½ cups quick-cooking oats
½ teaspoon baking soda

1 tablespoon baking powder

2 cups chopped cranberries

¾ cup (1½ sticks) margarine, softened

1 cup sugar

1 cup milk

3 large eggs

2 teaspoons orange extract

Yogurt Glaze (page 160)

- 1. Preheat the oven to 350°F. Grease and flour a 10-inch tube pan.
- 2. In a large bowl, combine the flour, oats, baking soda, and baking powder, then stir in the cranberries. In a separate bowl using an electric mixer, cream together the margarine and sugar until light and fluffy. Add the milk, then the eggs, one at a time, beating after each addition. Stir in the orange extract. Add the dry ingredients and mix until uniform. Pour the batter into the prepared pan and bake for about 60 minutes or until a cake tester inserted in the center comes out clean. Cool in the pan for 10 minutes, then turn out onto a rack to cool completely. Serve drizzled with Yogurt Glaze.

Banana Chip Cake

Serves 8 to 10

1½ cups sifted cake flour
¾ teaspoon baking soda
½ teaspoon salt
½ cup solid vegetable shortening
1 cup sugar
2 large eggs
¾ cup mashed banana (about 2 medium bananas)
1 cup semisweet chocolate mini morsels

- 1. Preheat the oven to 350°F . Grease and flour a 9-inch square pan.
- 2. In a large bowl, combine the flour, baking soda, and salt. Place the shortening in a separate bowl then, using an electric mixer, gradually add the sugar and cream until light and fluffy. Add the eggs, one at a time, beating after each addition. Blend in the banana. Add the dry mixture to the batter and stir well. Stir in the chocolate morsels. Pour the batter into the prepared pan and bake for 35 minutes or until a cake tester inserted in the center comes out clean. Cool in the pan on a rack to room temperature before removing from the pan.

Sour Cream Pound Cake

Serves 8 to 10

3 cups all-purpose flour
½ teaspoon baking soda
¼ teaspoon salt
1 cup (2 sticks) margarine, softened
3 cups sugar
6 large eggs
1 cup sour cream
2 teaspoons vanilla extract

- 1. Preheat the oven to 350°F. Grease and flour a 10-inch tube pan.
- 2. In a large bowl, combine the flour, baking soda, and salt. In a separate bowl using an electric mixer, cream together the margarine and sugar until light and fluffy. Add the eggs, one at a time, beating after each addition. Stir in the sour cream and vanilla. Add the dry ingredients and mix well. Pour the batter into the prepared pan and bake for 1 hour and 25 minutes or until a cake tester inserted in the center comes out clean. Cool in the pan for 10 minutes, then turn out onto a rack to cool completely.

Almond Pound Cake

Serves 8 to 10

Cover this with cake with Chocolate Glaze (page 162), and the perfect snack cake becomes the perfect dessert cake.

2 cups all-purpose flour

1/4 teaspoon baking soda

11/2 teaspoons cream of tartar

1 cup (2 sticks) margarine

1 cup sugar

7 ounces almond paste

4 large eggs

1/2 cup milk

Chocolate Glaze (optional) (page 162)

- 1. Preheat the oven to 350°F. Grease and flour a Bundt pan.
- 2. In a large bowl, combine the flour, baking soda, and cream of tartar. In a separate bowl using an electric mixer, cream together the margarine, sugar, and almond paste. Beat in the eggs, one at a time, until light and fluffy. Beat in the dry mixture alternately with the milk, beginning and ending with the dry mixture, beating until uniform. Pour the batter into the prepared pan and bake for 1 hour and 10 minutes or until a cake tester inserted in the center comes out clean. Cool in the pan for 10 minutes, then turn out onto a rack to cool completely. Drizzle with Chocolate Glaze if you like.

Bourbon Cake

Serves 8 to 10

2½ teaspoon baking soda
½ teaspoon salt
1 cup (2 sticks) butter or margarine, softened
2 cups sugar
1 cup sour cream
3 tablespoons instant coffee granules
¼ cup bourbon
3 large eggs
1 teaspoon vanilla extract

- 1. Preheat the oven to 325°F. Lightly grease and flour a Bundt pan.
- 2. In a large bowl, combine the flour, baking soda, and salt. In a separate bowl, using an electric mixer cream together the butter and sugar until light and fluffy. Add the sour cream. Combine the coffee with the bourbon and stir to dissolve. Add to the creamed mixture. Beat in the eggs, one at a time, and then the vanilla. Add the dry ingredients to the creamed mixture. Pour the batter into the prepared pan and bake for 50 to 60 minutes or until a cake tester inserted in the center comes out clean. Cool in the pan for 10 minutes, then turn out onto a rack to cool completely.

Brownie Bread

Serves 8 to 10

1½ cups all-purpose flour
1½ cups sugar
6 tablespoons cocoa powder
1 tablespoon instant coffee granules
1 teaspoon baking soda
¾ teaspoon salt
1 cup coarsely chopped toasted walnuts
1 large egg
1½ cups sour cream
4 tablespoons butter, melted and cooled
½ teaspoon vanilla extract

- 1. Preheat the oven to 350° F. Grease a $9 \times 5 \times 2^{1/2}$ -inch loaf pan and line the bottom with buttered wax paper. Dust the bottom and sides of the pan with flour; shake out any excess.
- 2. In a large bowl, combine the flour, sugar, cocoa powder, coffee granules, baking soda, and salt, then stir in the walnuts. In a separate bowl, whisk together the egg, sour cream, melted butter, and vanilla. Add the dry ingredients to the liquid mixture and stir until just blended. Pour the batter into the prepared pan and bake for about 1 hour and 10 minutes or until a cake tester inserted in the center comes out clean. Cool in the pan for 10 minutes, then turn out onto a rack to cool completely. Wrap with plastic and let stand in a cool place for at least 1 day before slicing.

Extra-Chocolate Cake

Serves 8 to 12

This great cake is even better covered in Fudge Frosting (page 161).

2 cups cake flour
1 teaspoon baking soda
3/4 teaspoon salt
1/2 cup solid vegetable shortening
11/2 cups brown sugar
2 large eggs
3 ounces unsweetened chocolate, melted
1 teaspoon vanilla extract
1 cup plus 2 tablespoons milk
Fudge Frosting (page 161)

- 1. Preheat the oven to 350°F. Grease and flour two 9-inch round cake pans.
- 2. In a large bowl, combine the flour, baking soda, and salt. In a separate bowl using an electric mixer, cream together the shortening and brown sugar. Beat in the eggs one at a time, until the mixture is light and fluffy. Stir in the melted chocolate and vanilla. Beat in the dry ingredients alternately with the milk, beginning and ending with dry ingredients, beat until smooth and uniform. Pour the batter into the prepared pans and bake for 35 minutes or until a cake tester inserted in the center comes out clean. Cool in the pans for 10 minutes, then turn out onto racks to cool completely before frosting.

Super Chocolate Cake

Serves 8 to 10

Make sure to put this one under some Fudge Frosting (page 161).

2¾ cups cake flour
1 teaspoon baking soda
¼ teaspon salt
¾ cup (1½ sticks) margarine
6 ounces semisweet chocolate
1½ cups sugar
3 large eggs
2 teaspoons vanilla extract
1½ cups water
Fudge Frosting (page 161)

- 1. Preheat the oven to 350°F. Grease and flour two 9-inch round cake pans.
- 2. In a large bowl, combine the flour, baking soda, and salt. In a medium saucepan over medium-low heat, carefully melt the margarine and chocolate together, stirring continuously. As soon as the chocolate is completely melted remove from the heat. Stir in the sugar, then transfer the mixture to a large bowl. Using an electric mixer, beat in the eggs, one at a time, until smooth. Add the vanilla. Stir in ½ cup of the dry mixture. Beat in the remaining dry mixture alternately with the water until smooth and uniform. Pour the batter into the prepared pans and bake for 35 minutes or until a cake tester inserted in the center comes out clean. Cool in the pans for 10 minutes, then turn out onto to racks to cool completely before frosting.

Chocolate Milk Cake

Serves 8 to 10

13/4 cups all-purpose flour
1 teaspoon baking soda
1 teaspoon cream of tartar
1/2 cup (1 stick) butter or margarine
1 cup sugar
1/2 cup cocoa powder or instant hot chocolate powder
1/4 cup very hot water
1 cup milk
1 large egg
1 teaspoon vanilla extract

- 1. Preheat the oven to 375°F. Lightly grease and flour a 9-inch square baking pan.
- 2. In a large bowl, combine the flour, baking soda, and cream of tartar. In a separate bowl, cream the butter and sugar. In another bowl, dissolve the cocoa in the hot water, cool slightly, then add to the creamed mixture. Add the milk, egg, and vanilla and mix well. Stir in the dry mixture. Pour the batter into the prepared pan and bake for 30 minutes or until a cake tester inserted in the center comes out clean. Cool in the pan for 10 minutes, then turn out onto a rack to cool completely.

Rhubarb Coffee Cake

Serves 8 to 10

Cake

2 cups all-purpose flour
1 teaspoon baking soda
½ teaspoon salt
½ cup butter-flavored shortening
1½ cups packed brown sugar
1 large egg
1 cup sour cream
1½ cups chopped rhubarb

Topping

1/4 cup granulated sugar
 1/4 cup packed brown sugar
 1/2 cup chopped walnuts
 1 tablespoon margarine
 1 teaspoon ground cinnamon

- **1.** Preheat the oven to 350°F. Lightly grease and flour a 9×12 -inch baking pan.
- 2. In a large bowl, combine the flour, baking soda, and salt. In a separate bowl using an electric mixer, cream together the shortening and sugar, then add the egg. Add the dry ingredients to the creamed mixture alternately with the sour cream. Fold in the rhubarb. Pour the batter into the prepared pan. In a medium bowl, combine all the topping ingredients and sprinkle over the batter. Bake for 45 to 50 minutes or until a cake tester inserted in the center comes out clean. Cool in the pan for 10 minutes, then turn out onto a rack to cool completely.

Yogurt Glaze

Make this the finishing touch for Cranberry Cake (page 150) or any snack cake or quick bread.

1½ cups plain nonfat yogurt3 tablespoons brown sugar2 teaspoons vanilla extract

In a medium bowl, combine all the ingredients and mix well until smooth.

Judge Frosting

This is the perfect chocolate lover's frosting to spread over Extra-Chocolate Cake (page 156) or Super Chocolate Cake (page 157).

1 cup granulated sugar 4 tablespoons cocoa powder 4 tablespoons butter ½ cup milk 2 tablespoons corn syrup 1 cup confectioners' sugar 1 teaspoon vanilla extract

In a medium heavy saucepan over medium heat, combine the granulated sugar, cocoa, butter, milk, and corn syrup. Bring to a boil, stirring frequently. Remove from the heat and transfer to a bowl. Add the confectioners' sugar and vanilla and beat until spreading consistency.

Chocolate Glaze

When chocolate frosting is too much, but plain won't do, this glaze will lightly dress up your cake.

- 5 tablespoons margarine
- 2 ounces unsweetened chocolate
- 2 cups confectioners' sugar
- 2 tablespoons hot water
- 2 teaspoons vanilla extract

In a medium saucepan over medium heat, melt the margarine with the chocolate. Add the confectioners' sugar, water, and vanilla and stir until well blended. If the glaze is too thick, add additional hot water, 1 tablespoon at a time, until you reach desired consistency.

The Alternative Baking Soda Alternative

Even baking soda aficionados are subject to the lure of convenience when using their favorite alternative to formulated cleaners. So now there is an alternative baking soda alternative. It comes in a handy container, it requires no mixing, and it even smells good. It's baking soda toothpaste, of course. Baking soda toothpaste is composed of three major ingredients—baking soda, water, and a mild detergent. In the first section of the book I've suggested using a paste of baking soda, water, and a few drops of gentle dishwashing detergent or liquid soap. Baking soda toothpaste combines all three, in addition to some miscellaneous ingredients. When you can't keep a box of baking soda handy, try a tube of baking soda toothpaste instead. For the full baking soda benefit, use a paste rather than a gel product. The pastes generally contain a higher baking soda content.

The guidelines for using baking soda toothpaste are the same as described earlier for using baking soda itself. Please review these common sense recommendations once more. Remember to test-clean a small, inconspicuous area first to check for colorfastness and general compatibility. Handle baking soda toothpaste with the same care accorded any other household product. Above all, keep it out of

the reach of children. It is designed to taste good, but not to be ingested. This is particularly true of products containing fluoride. Sodium fluoride, the most widely used anticavity ingredient, is harmless for brushing teeth, but poisonous if ingested in large enough quantity. Be sure to thoroughly rinse any food or food contact surface that is cleaned with a fluoride-containing toothpaste. A non-fluoride product is recommended for the uses described here.

ALL THROUGH THE HOUSE

The following items can be cleaned of dirt, grime, mildew, and stains with a dab of baking soda toothpaste on a wet sponge or nylon scrubber. If the paste seems too dry or thick as you're rubbing it in, just sprinkle with a little water. In all cases, rinse well after scrubbing and then dry.

Hard-skinned fruit and vegetables (rinse well)
Stained plastic, glass, ceramic or nonaluminum metal
containers

Glass and stainless steel coffee pots
All nonaluminum and nonstick cookware

Plastic cups and dishes

Chinaware

Pewterware

Wood and plastic cutting boards (rinse well) Ceramic tile countertops and backsplashes Butcher block counters and tabletops Plastic laminate counters and tabletops

Plastic laminate table seams

The Alternative Baking Soda Alternative

Metal chair and table legs Standard (not self- or continuous-clean) ovens

Stovetops Stove backsplashes

Electric range catch pans

"Fingerprinted" enamel appliances

Small plastic appliances (mixers, blenders, etc.)

Inside surfaces of refrigerators, freezers, automatic dishwashers, and microwave ovens

Door gaskets on refrigerators, freezers, and automatic dishwashers

Washable (plastic laminate, enamel) cabinets

Refrigerator drip tray

Vinyl upholstery

Black heel marks and crayon on linoleum and vinyl flooring

Stainless steel, porcelain, and enamel sinks

Baby's high chair

Glazed ceramic floor and wall tile

Tile grout

Fiberglass sinks, tubs, and showers

Plastic shower curtains

Glass shower doors

Mirrors and windows

Metal, porcelain, and ceramic plumbing fixtures

Crayon and wax on washable hard surfaces

Metal baseboards

White baby shoes

Plastic dolls

Plastic toys (be careful around decals)

Pet cages (remove the pet first)

Marble-top furniture

Baking Soda Bonanza

Unlacquered metals: chrome, stainless steel, silver, gold, pewter, copper, brass, bronze

Plastic, fiberglass, hard rubber, and painted aluminum sports equipment

Golf balls, volleyballs, soccer balls, bocci balls, bowling balls, baseballs

Computer mouse ball (remove from mouse first)

Automobile windows, headlights, chrome, vinyl tops, and canvas tops

Sap-stained auto paint (use sparingly and keep wet)

Fiberglass auto and boat panels

Plastic seats on swing sets

Plastic and glass patio furniture

Bibliography

- American Chemical Industry: A History, William Haynes. New York: Van Nostrand, 1949.
- American Food, Evan Jones. New York: Dutton, 1975.
- Appleton's Cyclopaedia of American Biography, James Grant Wilson and John Fiske. New York: Appleton, 1887.
- A Bibliography for Culinary Historians Using the Harvard University Libraries and the Arthur and Elizabeth Schlesinger Library of the History of Women in America, Barbara Ketcham Wheaton and Patricia M. Kelly. Cambridge, MA, 1985.
- The Book of Bread, Judith and Evan Jones. New York: Harper and Row, 1982.
- Carla Emery's Old Fashioned Recipe Book, Carla Emery. New York: Bantam, 1977.
- The Chemistry of the Arts, Arthur L. Porter. Philadelphia: Carey and Lea, 1830.
- The Complete Food Handbook, Roger P. Doyle and James L. Redding. New York: Grove Press, 1976.

Bibliography

- A Comprehensive Treaty on Inorganic and Theoretical Chemistry, J. W. Mellor. London: Longmans, 1927.
- Concise Dictionary of American Biography, 2nd ed., New York: Scribner's, 1977.
- The Cook's Companion, Dorris McFerran Townsend. New York: Crown, 1978.
- Dictionary of American Biography, Allen Johnson. New York: Scribner's, 1928.
- The Dictionary of Medical Folklore, Carol Ann Rinzler. New York: Thomas Y. Crowell, 1979.
- Dictionary of National Biography, Leslie Stephen and Sidney Lee. Oxford: Oxford University Press, 1917.
- Dictionary of Scientific Biography, New York: Scribner's, 1972.
- Eating in America, Waverly Root and Richard de Rochemont. New York: William Morrow, 1976.
- Encyclopedia of Chemical Technology, Raymond E. Kirk and Donald F. Othmer. New York: Wiley, 1st ed., 1948; 2nd ed., 1964, 1978; 3rd ed., 1984.
- English Bread and Yeast Cookery, Elizabeth David. New York: Viking, 1980.
- The Food Book, James Trager. New York: Grossman, 1970.
- Food in History, Reay Tannahill. New York: Stein and Day, 1973.
- Foods and Nutrition Encyclopedia, Clovis, CA: Pegus Press, 1983.

- Geology and World Deposits, Peter W. Harben and Robert L. Bates. London: Metal Bulletin Plc, 1990.
- The Goldbeck's Guide to Good Food, Nikki and David Goldbeck. New York: New American Library, 1987.
- The Grains Cookbook, Bert Greene. New York: Workman Publishing, 1988.
- Great American Food Almanac, Irena Chalmers and Milton Glaser. New York: Harper and Row, 1986.
- Great Oldtime Recipes, Beatriz-Maria Prada. New York: Ballantine, 1974.
- A History of American Manufacturers from 1608 to 1860, J. Leander Bishop. London: Edward Young, 1868.
- History of the City of New York 1609–1909, John William Leonard. New York: Journal of Commerce and Commercial Bulletin, 1910.
- The Ingenious Yankees, Joseph and Frances Geis. New York: Thomas Y. Crowell, 1976.
- Inventors Who Left Their Brands on America, Frank H. Olsen. New York: Bantam, 1991.
- Kitchen Science, Howard Hillman. Boston: Houghton Mifflin, 1989.
- Listening to America, Stuart Berg Flexner. New York: Simon and Schuster, 1982.
- Made in USA, Phil Patton. New York: Grove Weidenfield, 1992.
- On Food and Cooking, Harold McGee. New York: Scribner's, 1984.

Bibliography

- The Secret Life of Food, Martin Elkort. Los Angeles: Jeremy P. Tarcher, 1991.
- Sodium Bicarbonate. Princeton, NJ: Church and Dwight, 1989.
- The Supermarket Handbook, Nikki and David Goldbeck. New York: New American Library, 1976.
- The Versatile Grain and the Elegant Bean, Sheryl and Mel London. New York: Simon and Schuster, 1992.
- Who Was Who in America, Chicago: Marquis, 1963.

Index

accident cleanup: after bed-wetting, 30 pet, 35 acid lake recovery, 78 acid rain relief. 79 acid stain spotter, 51 aftershave, 28 air, as leavening agent, 96-97 air mattress cleaner, 67 all-purpose cleaner, 58 all-purpose flour, 87 almond pound cake, 153 aluminum cleaner, 68 amaranth (flour), 89 -buttermilk bread, 111 American Cookery (Simmons), 4 American Dental Association, 13 American Revolution, 4 animal crackers, 135 antacids, 22 apple: -bran bars, 136 -nut muffins, 116 appliance bleach, 37 apricot-orange cookies, 128 aquarium stabilizer, saltwater. Arm & Hammer, 9-10 art marker cleanup, 32

ashtray cleaner, 58

baby bottle cleaner, 30 baby clothes: new, detox for, 30 refresher, 30-31 baby high chair cleaner, 44 baby movers cleaner, 30 baby shoes cleaner, 33 baby stroller cleaner, 30 bad breath, elimination of, 14 baking, 3-11 flour and, 85-92 leavening agents and, 92–97 other ingredients and, 97-99 pearlash used in, 3-4 process of, 100-102 saleratus and, 5–10 See also specific recipes baking powders, 10, 93-94 baking soda: buffering properties of, 18 discovery and development of,

3 - 11

first use of term, 9 forms for use of, 21–22

other names for, xi

balloon blower, 54

as "greenest" chemical, xii

athlete's foot treatment, 22-23

automobile uses, 30, 63-67

bread: balls, cleaning, 68 brownie, 155 banana: buttermilk amaranth, 111 chip cake, 151 carrot cake, 108 -oat raisin muffins, 124 date-nut, 106 barley flour, 89 easy brown, 147 baseboard cleaner, 61 graham, 148 bathing suit soak, 51 harvest, 113 bathroom uses, 48-51 peanut butter, 107 baths: pumpkin, 112 foot, 26 simple soda, 115 plastic doll, 55 zucchini, 114 sponge, 29 See also corn bread bath salts, 23 bread flour, 87 battery acid neutralizer, 64 breakfast recipes, 137–49 battery terminal cleaner, 64 brightener, laundry whites, 52 bedding: bromated flour, 88 cleaning and deodorizing, 30, brown bread muffins, 123 brownie bread, 155 milk, food and spit-up stain bubbling bath salts, 23 pretreatment, 33 buckwheat (flour), 89 bed-wetting response, 30 pancakes, 143 berry-yogurt muffins, 121 buffering properties of baking big and easy oatmeal cookies, soda, 18 125 Burgin & Sons, 8 birdbath cleaner, 681 burner catch pad cleaner, 37 birthday cookie, 126 burn soothers, 23–24 biscuits, cinnamon drop, 138 burnt-on food releaser, 38 Bisogni, James, Jr., 78 buttermilk: bite relief, insect, 27 -amaranth bread, 111 blackhead buster, 23 graham pancakes, 139 bleach: extender, 51 cabinet deodorizer, bathroom, for white appliances and sinks, 37 cages, pet, cleaning, 35 bloodstain scrub, 52 boat uses, 63-67 cake flour, 88 cakes, 150-59 body, human, xi camper's comrade, 68 book deodorizer, 61 campfire controller, 69 bottle cleaner, baby, 30 bourbon cake, 154 Canada, 7-10 canker sore relief, 24 bran-apple bars, 136 canvas cleaners, 67 brass cleaner, for boats, 67

carbon dioxide, xi, 5, 6 comb cleaner, 48 leavening agents and, 97, 100 baby's, 31 pearlash and, 3 contact lens storage fluid, 24 carpet cleaners, 62-63 containers, food, deodorizing, for boats, 65 43 carpets, pet accident deodorizer, cookies, 125-36 cookout fire extinguisher, 69 carrot cake bread, 108 cookware, nonstick, cleaning, 45 cars. See automobile uses corn bread: cattle, baking soda consumption nouvelle, 110 by, 11–12 old-fashioned, 109 CD and DVD cleaner, 58-59 corn flour, 89 chocolate: cornmeal pancakes, 140 glaze, 162 Cow Brand Soda, 9-10 -peanut butter cookies, 130, 131 crackers: chocolate cake: animal, 135 extra-, 156 graham, 134 super, 157 cradle cap treatment, 31 chocolate chip cookies: cranberry cake, 150 birthday, 126 crayon remover, 33 redux, 127 cruet cleaner, 40 chocolate milk cake, 158 crystal spot remover, 40 chrome cleaner, 65 curtains, shower, cleaning, 50 for boats, 67 cuticle softener. 24 Church, Austin, 6-10, 13, 17 cutting board deodorizer, 40 Church, Elihu, 8 Church, James, 8 dancing seeds, 55 Church & Company, 8-9 date-nut bread, 106 cinnamon drop biscuits, 138 deck furniture cleaner, 70 clay, play, 57 delicate clothes, 52 cleanser, 38 dental care, xi, xii, 13-14, 29, scouring, 38 165 - 66cleanups cleaner, 38 for dogs, 35 closet deodorizer, 59 dental device cleaner, 25 bathroom, 48 denture cleaner, 25 clothes, cleaning, 51-54 deodorant, 25 doll, 55 deodorizing, 20 cloth seat cleaner, 39 See also specific uses coffee maker cleaner, 42 desserts: coffee pot cleaner, 39 cakes, 150-59 coffee stain remover, 39 chocolate glazes, 162 color magic, 55 cookies, 125-36

desserts (continued) fudge frosting, 161 yogurt glaze, 160 detergents, dishwashing, 41 diamond ring cleaner, 59 diaper pail relief, 31 diaper rash soother, 32 digestion, in cattle, 11–12 dishwasher cleaner, 41 dishwashing detergent booster, liquid, 41 dog dental care, 35 dolls, cleaning, 55 drain cleaners: bathroom, 48 kitchen, 41-42 drink, sports, 72 drip coffee maker cleaner, 42 drip tray cleaner, 42 dry cleanables, 52 Dwight, John, 7, 13, 17 Dwight's Salertus, 7-10

earwax softener, 25
easy brown bread, 147
eggnog cookies, 133
eggs, 98
elbow scrub, 25
English muffin loaves, 146
Environmental Protection
Agency, U.S., 82
environmental uses, xii, 77–82
Evans, Oliver, 4
every room uses, 58–63
extra chocolate cake, 156
eye cleaner, pet, 36
eve soother, 26

ear cleaner, pet, 36

fabric freshener, 53 fabric softener, 52 facial scrub, 26 feed, cattle, baking soda as supplement for, 11-12 fiberglass body cleaner, 65 fire extinguishers, 20-21 for automobiles and boats, 65 cookout, 69 fishing clothes deodorizer, 69 fishing equipment cleaner, 69 flatware cleaner, 43 floor cleaners for automobiles, 65 floor spotter, garage, 65 flour(s), 85-92 common wheat, 87-89 other, 89-91 wheat, 4, 7, 85-89 wheat substitutes, 91-92 See also baking flower vase filler, 59 food container deodorant, 43 food processor blade cleaner, 43 footprints, 56 foot soak, 26 foot softener, 26 French Academy of Sciences, 4 fresheners: baby clothes, 30-31 diaper pail, 31 fabric, 53 work clothes, 53 frosting, fudge, 161 fruit cleaner, 43-44 fruit juice stains, 54 fruity fiber muffins, 120 fudge frosting, 161 funnel cakes, 149 fur cleaner, pet, 36 furniture, cleaning, patio, 70

garage and dock uses, 63–67 garbage disposal cleaner, 44 garbage pail care, 44 garden glove cleaner, 69

garden mildeweide, 69 gargle, 27 Genesee Valley flour, 7 gingerbread waffles, 145 glass art, 56 glass cleaner: for automobiles, 65 for boats, 67 glaze: chocolate, 162 yogurt, 160 gloves, rubber, glide, 46 gluten flour, 88-89 graham (flour), 88 bread, 148 buttermilk pancakes, 139 crackers, 134 grass catcher care, 70 grease remover, kitchen, 40-41 grill cleaner, 70 grooming accessories cleaner, 48 grout stain removers, 48 gym bag deodorizer, 60

hairbrush cleaner, 48
baby's, 31
hair rinse, chlorine neutralizing, 24
hampers, 53
hand cleaner, 66
hand deodorizer, 44
hard surface cleaners, 49
hard wheat flour, 88
harvest bread, 113
heel mark remover, 47
high chair cleaner, 44
home care, xii, 14, 17–73
See also specific topics

icy step and porch traction aid, 73 industrial uses, xii insect bite and sting relief, 27 iron cleaner, 53

jelly muffins, 118 John Dwight and Company, 7–10

kitchen uses, 37–47 See also baking knee scrub, 27

Lady Maud (cow), 9 lake water, acid, 78 laundry uses, 33, 51–54 lawn furniture cleaner, 70 leather mildew remover, 60 leavening agents, 3–11, 92–97 air, 96–97 baking soda, 92–95, 100 baking soda discovery and development, 3–11 yeast, 10, 92, 95–96, 100 LeBlanc, Nicolas, 4–5 leg shave, 27 litter box deodorant, 36 luggage deodorizer, 60

marble cleaner, 60 marker, art, cleanup, 32 metal cleaners, 61 metal legs cleaner, 38 microwave oven cleaner, 45 mildew remover, leather, 60 milk, 99 stain pretreatment, 33

millet flour, 90
motion sickness response, for
automobiles and boats, 63
motorcycle maintenance, 67
mouthwash, 27
muffins, 116–24
multipurpose cleaners, 58
municipal water treatment, 77–78

Index

cage cleaner, 35 nail cleaner, 28 dish cleaner, 35 needlework cleaner, 61 nonstick cookware cleaner, 45 ear/eve/fur cleaner, 36 planter cleaner, 71 nouvelle corn bread, 110 plastic doll bath, 55 nursery: plastic food container cleaner, cleaner, 32 presoak, 31 plastic nursery items, cleaning, scrub, 32 nylon scrubber cleaner, 38 plastic toy cleaner, 56 playroom uses, 54–58 oat(meal): poison ivy relief, 28 -banana-raisin muffins, 124 pool care, 71-72: cookies, big and easy, 125 porcelain sink cleaner, 37 flour, 90 oceans, bicarbonate content of, xi potash, 3 potassium carbonates, 3-6 old-fashioned corn bread, 109 pound cake: orange: -apricot cookies, 128 almond, 153 sour cream, 152 -raisin scones, 137 outdoor uses, 67-73 preshave, 28 presoak, nursery, 31 oven cleaner, 45 prespotter, laundry, 53 oven glass cleaner, 45-46 pumpkin: bread, 112 paint stripping, 80-81 pancakes, 141 pancakes: puppy training aid, 37 buckwheat, 143 cornmeal, 140 graham buttermilk, 139 quick breads. See bread; muffins quinoa flour, 90 pumpkin, 141 pancake soufflé, 142 radiator cleaner, 61 patio umbrella and furniture rain, acid, 79 cleaner, 70 raisin: peanut butter: -oat-banana muffins, 124 bread, 107 -orange scones, 137 -chocolate cookies, 130, 131 rash soother, 28 pearlash, 3-5 diaper, 32 Pennsylvania Salt Manufacturing razor burn preventer, 28 Company, 8 Read, Nathan, 5 personal care, 22-29 refrigerator/freezer cleaner, 46 pet: refrigerators, deodorizing, xi, xii accident deodorizer, 34 rhubarb coffee cake, 158 bedding deodorizer, 35

Index

rice flour, 90 shower curtain cleaners, 50 ricotta cookies, 129 Simmons, Amelia, 4 ring-around-the-collar, 53 simple soda bread, 115 roach killer, 61 sink bleach, 37 Rochester, N.Y., 6-7 sleeping bag deodorizer, 68 room deodorizer spray, 59 snowman cookies, 132 rubber glove glide, 46 soap scum remover, 50 rug cleaner, 33 soda ash revolution, 4-5 rumen, 11-12 sodium aluminum phosphate, 94 running shoe deodorant, 62 sodium fluoride, 166 rust remover, 49 soil, saving, 81–82 RV toilet deodorizer, 72 soufflé, pancake, 142 rye flour, 90 sour cream pound cake, 152 sourdoughs, 96 safety concerns, 21-22, 165-66 soy flour, 90-91 sailor's scrub, 67 spa cleaner, 72 saleratus (aerated salt), 5-10 spatter spotter, 33 saliva: sponge bath, 29 of cows, 12 sponge/rubber cleaner, 38 human, xi, 13 sports: salt, 99 ball cleaner, 68 salts, bath, 23 drink, 72 saltwater aquarium stabilizer, equipment cleaner, 72 stainless steel cleaner, 47 San Francisco sourdough, 96 stain removers: sap remover, 28 coffee/tea, 39 scones, orange-raisin, 137 crayons, 33 scouring cleanser, 38 grease, 40-41 scrub brush cleaner, 38 for grout, 48 scuff mark remover, 47 heel marks, 47 seat cleaners: for marble, 60 cloth, 39 for upholstery and carpet, upholstery, 63 62 - 63vinyl, 47, 67 wine, 54 self-raising flour, 88 stalagmites and stalactites, 57-58 septic tank saver, 49 staling of baked goods, 101–2 shampoo helper, 29 Statue of Liberty, restoration of, shoes: baby, cleaning, 33 sting relief, insect, 27 running, deodorizing, 62 stomach, xi shoofly muffins, 122 stovetop parts and surface shortening, 97–98

cleaners, 40-41

stroller cleaner, 30 stuffed toy cleaner, 33–34 stuffy nose relief, 34 sugar, 99 yeast and, 95 sulfur dioxide, removal of, 79 super chocolate cake, 157 sweet potato muffins, 117 swing seat cleaner, 73

tabletop scrub, 47
tea stain remover, 39
teeth. See dental care
teff flour, 91
tent cleaner, 73
toilet bowl cleaners, 50
toothbrush cleaner, 29
toothpastes, xi, xii, 29, 165–66
tooth whitener, 29
toy box cleaner, 58
toy cleaner, 33–34
traction action, for icy steps and
porch, 73
triticale flour, 90–91

umbrellas, patio, cleaning, 70 unbleached flour, 87 upholstery, pet accident deodorizer, 34 upholstery cleaners, 62–63 cloth, 39 vinyl, 63, 67

vinyl cleaner:
kitchen, 47
upholstery, 63, 67
for vehicle seats and top, 67
vomit control, 34
for automobiles and boats, 63
Vulcan Spice Mills, 8–9

waffle iron cleaner, 47 waffles, 144 gingerbread, 145 walnut: -apple muffins, 116 -date bread, 106 washer deodorizer, 54 washer/dryer cleaner, 54 wastebasket deodorizer, bathroom, 50 waste treatment, 79 water, acid, 78 water spot remover, bathroom fixtures, 51 water stabilizer, in swimming pools, 71-72 water treatment, municipal, 77–78 wax remover, 63 wheat, 4, 7 white appliance and sink bleach, whites brightener, laundry, 52 whole wheat flour, 88 window blinds cleaner, 63 windshield and chrome cleaner, 65 wine stains, 54 Wolf Pond, 78 work clothes freshener, 53

yard uses, 67–73 yeast, 10, 95–96, 100 baking process and, 100 yogurt: -berry muffins, 121 glaze, 160

zucchini: bread, 114 muffins, 119